G000136758

COBHAM
From Old Photographs

PETER F. CORNELL

AMBERLEY

First published 2013

Amberley Publishing
The Hill, Stroud
Gloucestershire, GL5 4EP

www.amberley-books.com

Copyright © Peter F. Cornell, 2013

The right of Peter F. Cornell to be identified as the Author
of this work has been asserted in accordance with the
Copyrights, Designs and Patents Act 1988.

All rights reserved. No part of this book may be reprinted
or reproduced or utilised in any form or by any electronic,
mechanical or other means, now known or hereafter invented,
including photocopying and recording, or in any information
storage or retrieval system, without the permission in writing
from the Publishers.

British Library Cataloguing in Publication Data.
A catalogue record for this book is available from the British Library.

ISBN 978 1 4456 1924 8 (print)
ISBN 978 1 4456 1930 9 (ebook)

Typeset in 10pt on 12pt Sabon.
Typesetting and Origination by Amberley Publishing.
Printed in the UK.

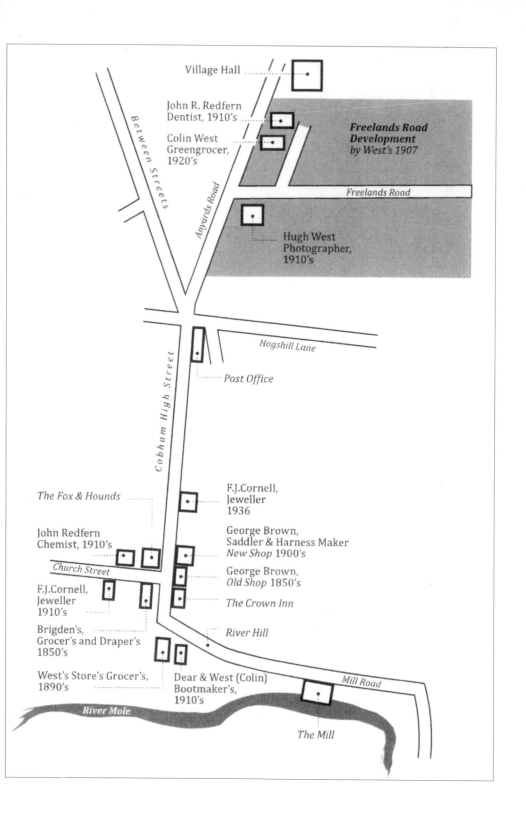

Village Hall

John R. Redfern
Dentist, 1910's

Colin West
Greengrocer,
1920's

*Freelands Road
Development
by West's 1907*

Freelands Road

Hugh West
Photographer,
1910's

Hogshill Lane

Post Office

The Fox & Hounds

F.J.Cornell,
Jeweller
1936

John Redfern
Chemist, 1910's

George Brown,
Saddler & Harness Maker
New Shop 1900's

Church Street

George Brown,
Old Shop 1850's

F.J.Cornell,
Jeweller
1910's

The Crown Inn

Brigden's,
Grocer's and Draper's
1850's

River Hill

West's Store's Grocer's,
1890's

Dear & West (Colin)
Bootmaker's,
1910's

Mill Road

River Mole

The Mill

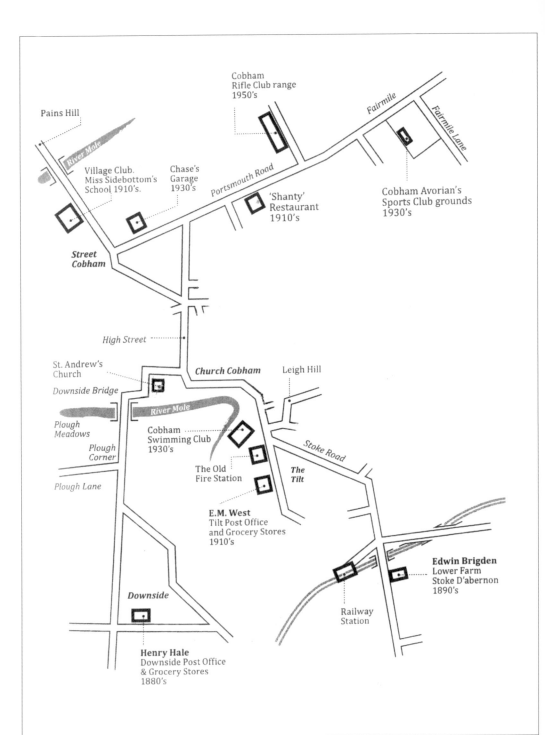

Introduction

Cobham is situated just within the M25 orbital motorway and Surrey commuting belt, 17 miles from central London on the London to Portsmouth road and 3 miles from Esher in the Elmbridge borough of Surrey. It has a long history: there was an Iron Age settlement at Leigh Hill, Roman remains have been found at Chatley, and the Normans built a church, now in Church Street, in the twelfth century. Early development took place in the eighteenth century at Street Cobham on the Portsmouth road, with the construction of inns for the coaches that passed through. In Victorian times, commercial activity was centered on Church Street. With the building of the railway line from London to Guildford, including Cobham station, in the 1880s, and the decline in the use of the horse due to the development of motor transport in the early 1900s, Cobham expanded.

This book offers glimpses of life in Cobham village from the photograph and picture postcard collections of six Cobham business families connected by marriage: the Wests, Brigdens, Hales, Browns, Redferns and Cornells.

James Brigden settled in Cobham in the late 1840s. He came from Storrington, Sussex. By the 1850s, he had established a general store, wine merchant's and draper's business on the corner of High Street and Church Street. In 1851, he employed a staff of seven at his premises. James's son Edwin took over Lower Farm, Stoke D'Abernon, in the 1890s, and two daughters, Elizabeth and Marianne, had a drapery and millinery business next to West's Stores in the 1910s.

William Henry West came to Cobham with his family, also from Storrington, in 1890 and purchased shop property at the corner of High Street and River Hill, where he started a provisions and wine merchant's business. In 1906, he purchased undeveloped land – a field off Anyards Road in the centre of the village – from the Bennett family. He constructed a road through its centre, which he called Freelands Road, and commenced building the first houses there. He built six on the left, and two on the right. In 1909, at the right-hand side of the entrance to Freelands Road, William's son Hugh built a photographer's studio and house. In 1922, William's youngest son Colin built a shop and house on their Freelands Road land, facing Anyards Road, where he started a fruiterer's and greengrocer's business. In 1910, William's eldest son Allen built

a shop and houses at the Tilt, where he opened a post office and general store, trading under his wife's name, E. M. West.

Frederick James Cornell, watchmaker and jeweller, arrived in Cobham in 1911 and opened his business at No. 7 Church Street, moving to No. 39 High Street in 1936. He was secretary of the Downside & Cobham Rifle Club before and after the First World War, and was in the Army in France with the 1st Battalion Tank Corps during the conflict. He was the rifle instructor for the Cobham Home Guard during the Second World War and helped to form the Cobham Rifle Club in 1949. He was an international marksman, representing Surrey, England and Great Britain on a number of occasions in rifle-shooting competitions versus the United States, Canada, Australia and Scotland from 1921–25.

Henry Hale settled in Cobham in the 1870s and was in business at the Downside post office, stores and bakery from the 1880s.

John Redfern came to Cobham and opened a chemist's business at Street Cobham in the 1880s, transferring to premises in Church Street, located just past the Fox & Hounds, in the 1910s. His son John R. Redfern was a dentist with a surgery at No. 32 Anyards Road, near the old Village Hall.

George Brown, saddle and harness maker, arrived in Cobham in the mid-1850s and established his business at property he bought in the High Street, opposite the entrance to Church Street. Under the proprietorship of his descendents, the business evolved into a general leather shop, and then a sports and games shop.

Since the Second World War, Cobham has seen the development of the A3 dual carriageway at Painshill and the M25 skirting Downside to the south. Superstores at Street Cobham and in the village centre have replaced the locally owned family stores. The post office has moved to from the High Street to Hollyhedge Road, and the old Village Hall in Anyards Road has been replaced with a new building nearby. Shops have been built at Oakdene Parade, north of the High Street.

Most of the views in this book portray changes that took place in the period that these families were settling in Cobham, from the late 1870s to the present day. The majority of the photographs taken prior to 1935 were taken by Hugh West, the Cobham Edwardian professional photographer, while the later ones were mainly taken by other members of the families. In a few cases this was not so. Every effort has been made to trace the copyright owners of these images; the author offers his sincere apologies to anyone he may have missed.

The author lived at Cobham for the first forty years of his life. He was born in Church Street in 1921, later moving to the High Street, and has many pleasant memories of the people and the village of Cobham. He would like to thank the staff at the Surrey History Centre for their help.

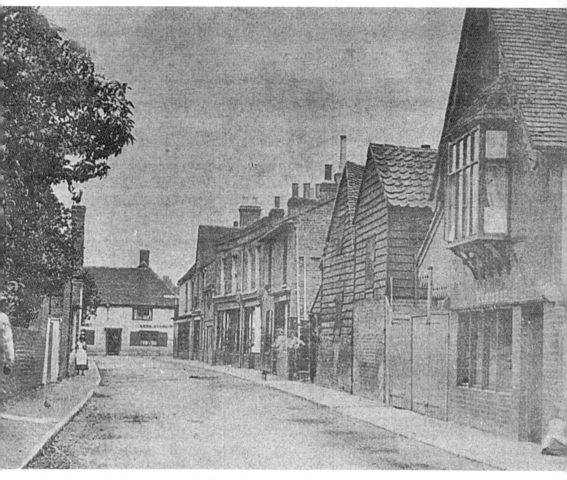

Church Street, looking towards the Crown Inn in the High Street, *c*. 1880. Bridgen's corner shop is seen here just right of the Crown, in the centre.

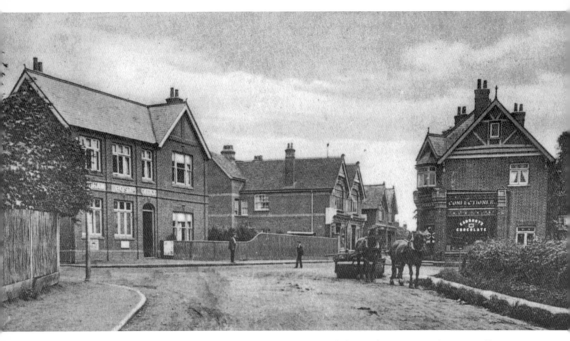

Cobham High Street, seen from Between Streets, in a postcard dating from 1903. The post office is on the left.

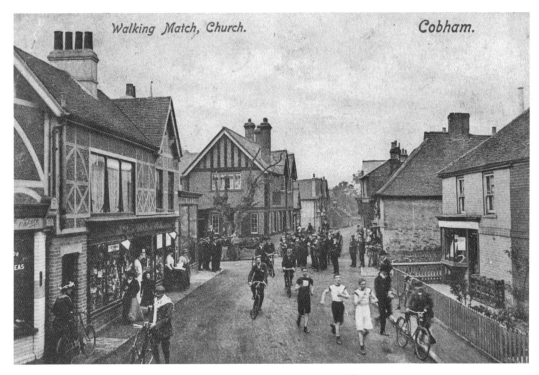

Walking match competitors in Cobham High Street approach River Hill, in 1904.

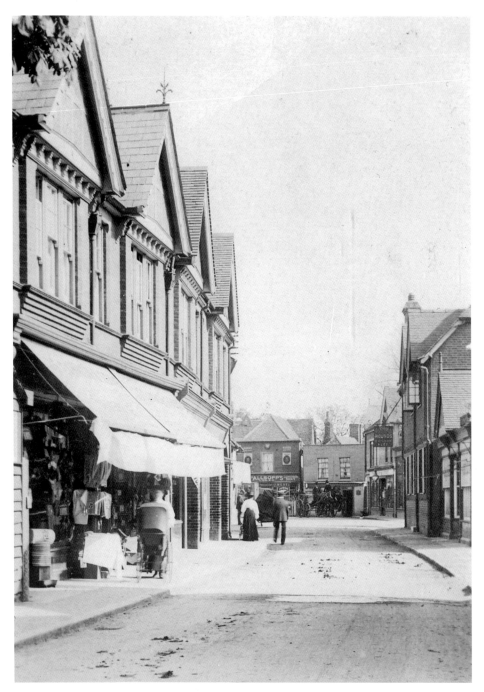

Cobham High Street around 1905, looking towards Church Street and River Hill. On the far right is Kippin's fishmonger's and greengrocer's, with the Fox & Hounds next door. On the left is Gammons' draper's.

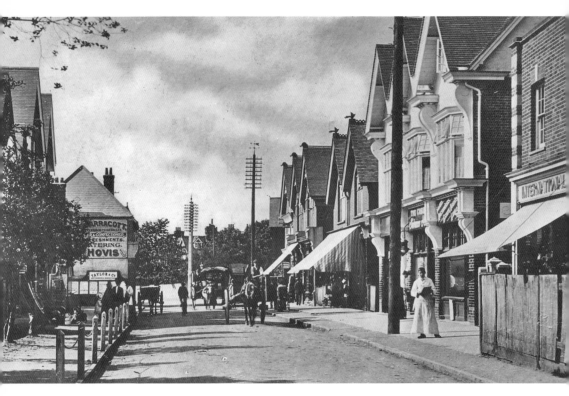

Cobham High Street looking towards the post office end, from a postcard dated 1908.

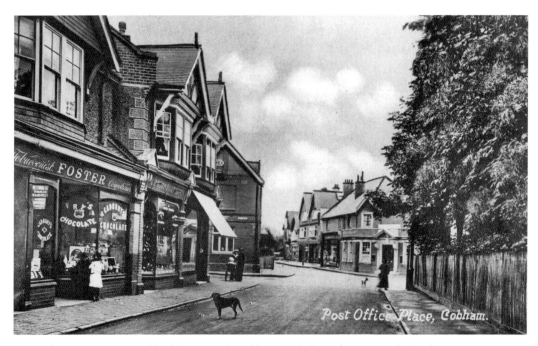

A view from a 1915 postcard looking towards Cobham High Street from Anyards Road.

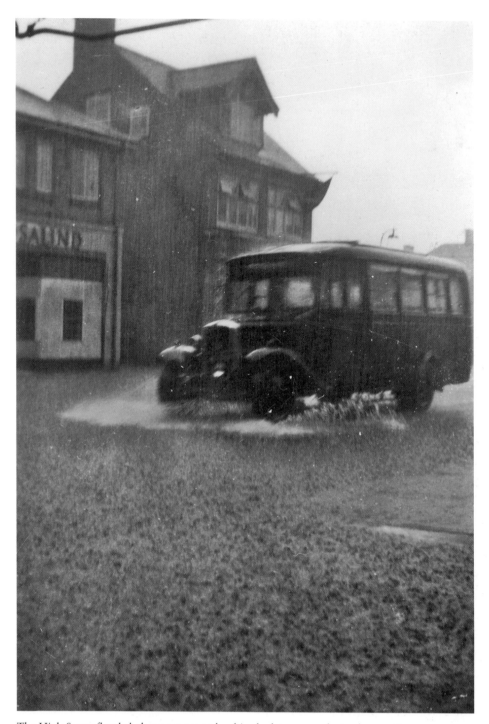

The High Street flooded above pavement level in the late 1930s during heavy rain.

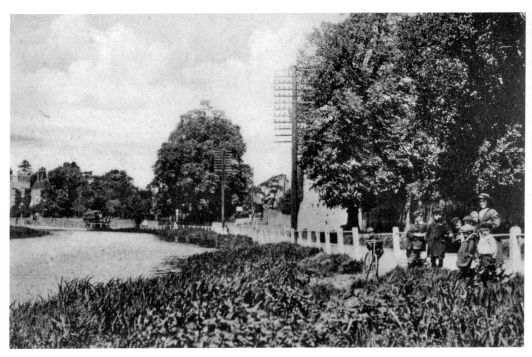

Major's Walk, Mill Road, Cobham, from a postcard dated 1903. Cedar House is on the left.

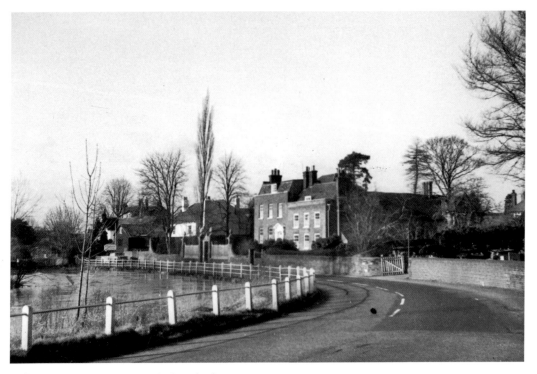

Cedar House in January 1965; it dates back over 500 years.

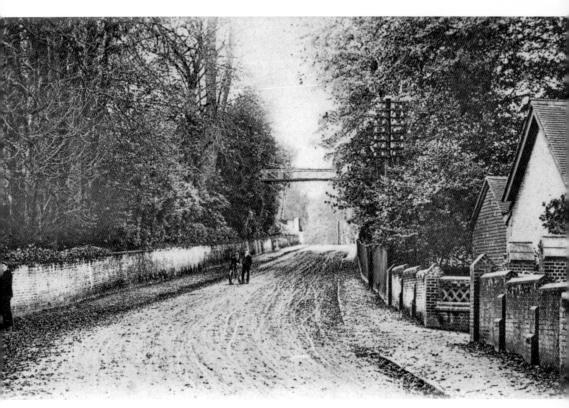

Painshill, in a postcard dating from around 1904.

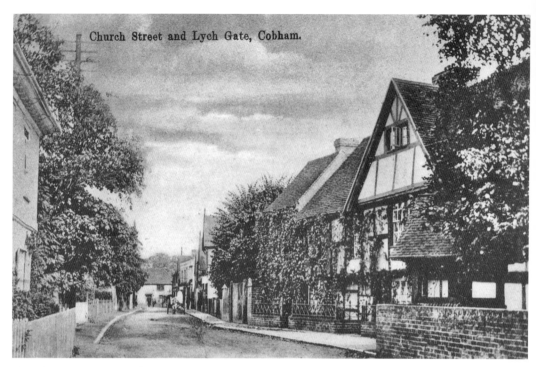

Church Street, *c.* 1916, with the lych-gate on the far right.

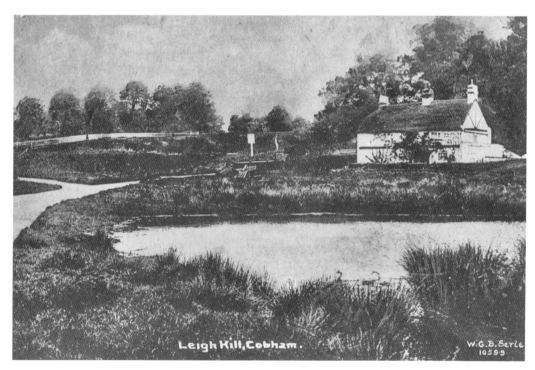

Leigh Hill and Pullens Cottage in around 1916.

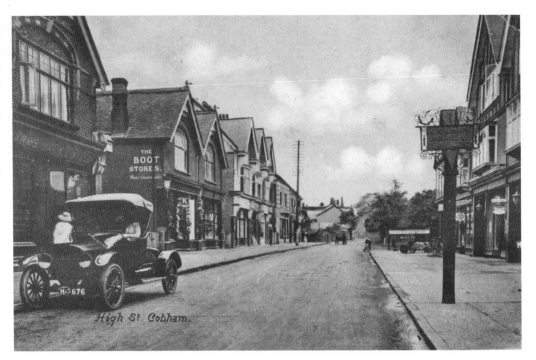

Cobham High Street, looking south in around 1917.

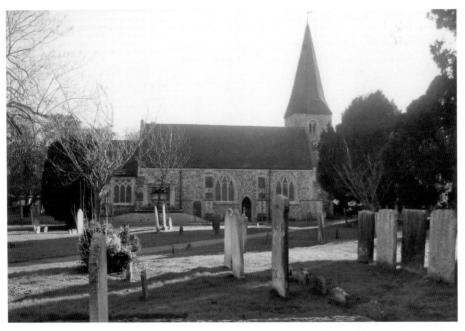

St Andrews, Cobham's parish church, dates back to the Norman era, having been built in the twelfth century. Though it has been extended and restored since that time, it still retains two Norman doorway arches and its Norman tower.

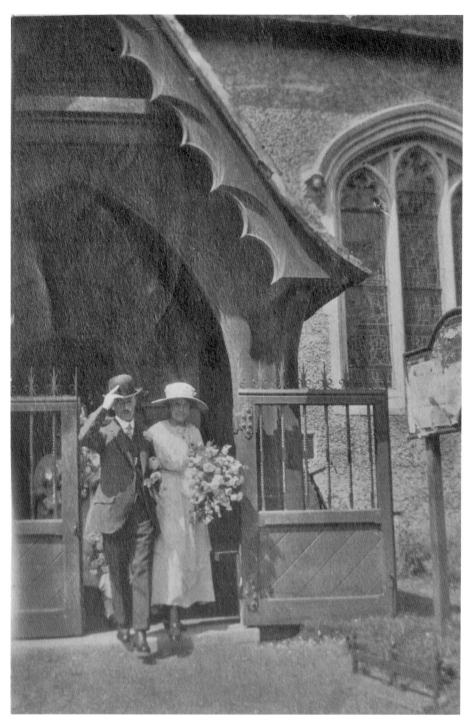

Frederick and Ethel Cornell leaving St Andrews church following their wedding on 19 June 1919.

Church Stile House, Church Street. An inscription on its front gives the date of 1432 and a restoration date of 1635, but 1432 is disputed.

Lime House in Church Street dates back to the eighteenth century.

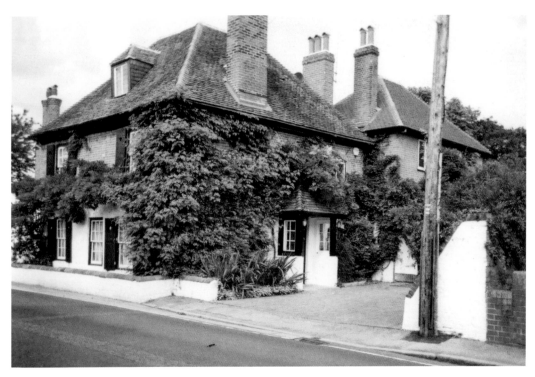

Overbye, in Church Street, also dates back to the eighteenth century.

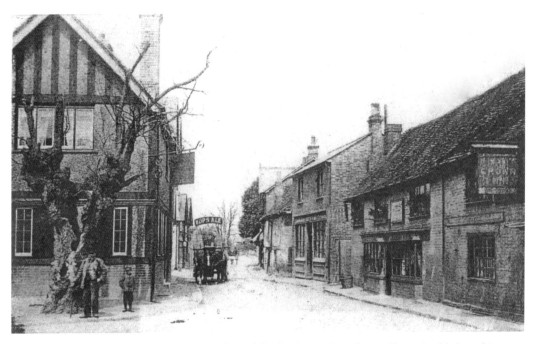

Cobham High Street around 1900. From right to left: the Crown Inn, George Brown's old shop, his new shop, and the Fox & Hounds.

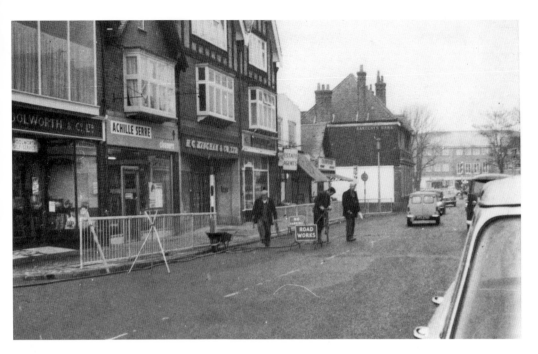

Above: Preparations for the new pedestrian crossing in the High Street, February 1965. Woolworths is on the far left.

Below: One month later and the crossing is complete.

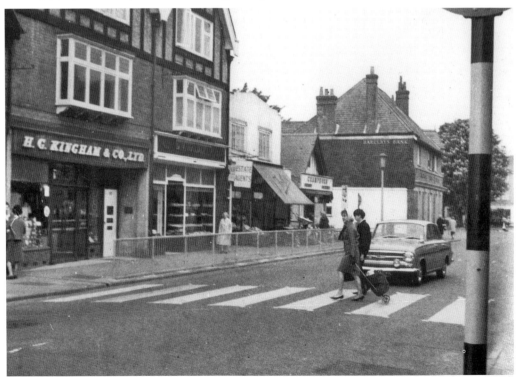

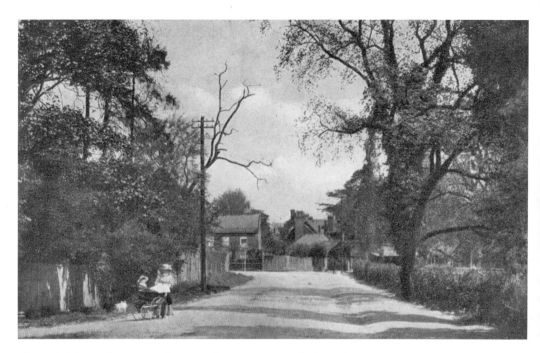

Above & below: These two early twentieth-century postcards show The Limes in Downside Road, the residence of Mr and Mrs James T. Bridgen. The lower image was taken from Downside Bridge and also shows St Andrew's church. The Limes is now called Church Cottage.

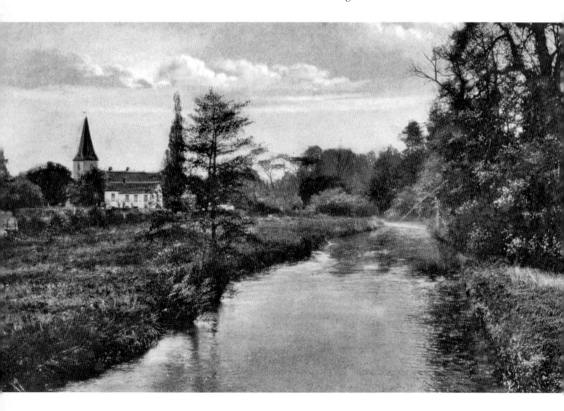

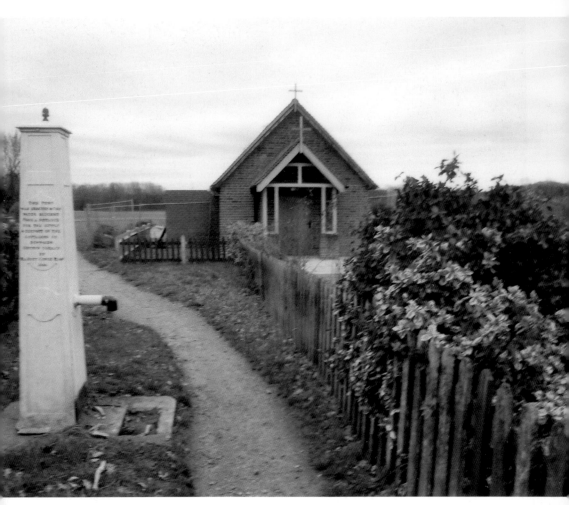

The village pump, installed in 1858, and St Michael's chapel, Downside.

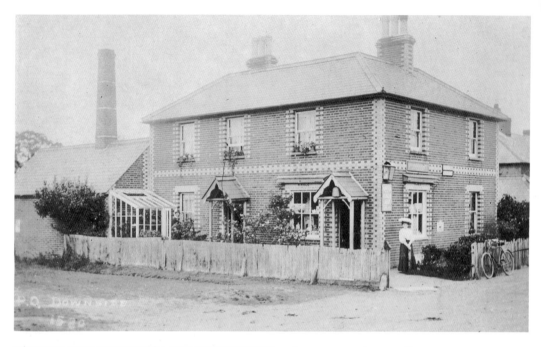

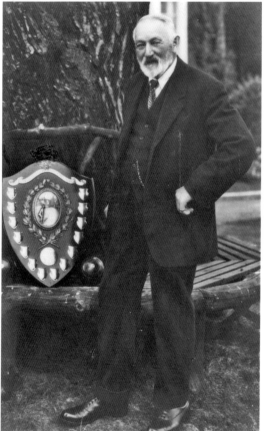

Above: Downside post office and stores around 1905, when it was run by Henry Hale. His bakery was on the left.

Left: Henry Hale, proprietor of Downside post office, stores and bakery, is seen here with a bowling trophy.

Pullens Cottage, Leigh Hill, dates back over 400 years.

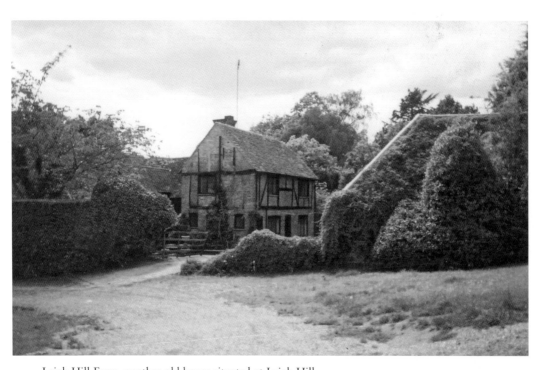

Leigh Hill Farm, another old house situated at Leigh Hill.

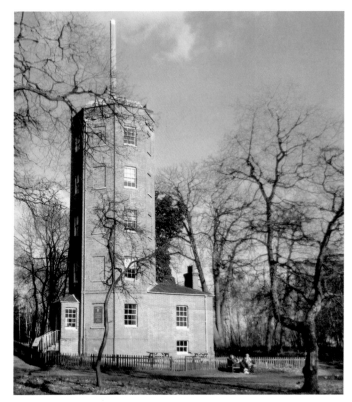

The restored semaphore tower, Chatley Heath, near Downside. It is one of a series of signalling stations from Portsmouth Harbour to London, built by the Admiralty in the early 1800s.

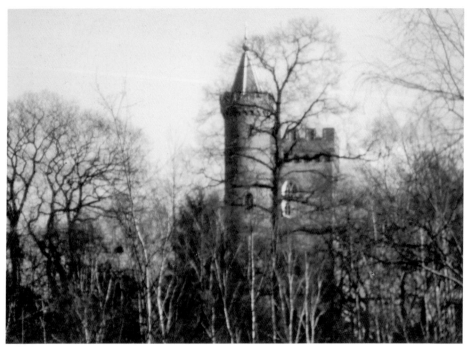

The eighteenth-century restored Gothic tower at Painshill.

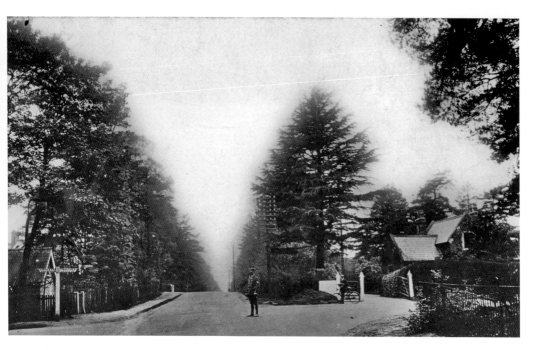

The crossroads on the Byfleet Road, just past Painshill, with an AA scout visible, around 1915. The Seven Hills Road, leading to Whiteley Village, is on the right. The road on the left, now a cul-de-sac, led to the Portsmouth Road. The signpost indicates the way to Ripley, Guildford and Walton.

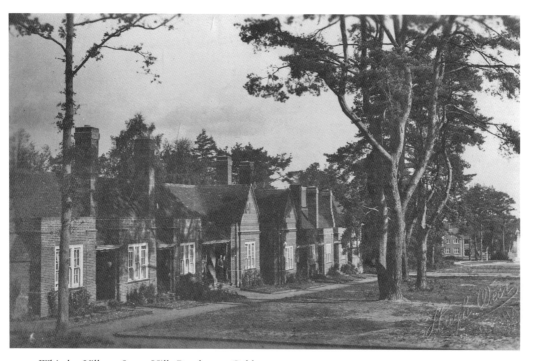

Whiteley Village, Seven Hills Road, near Cobham, 1922.

Plough Cottages, Plough Corner, Downside, date back to the eighteenth century.

The stile at Plough Meadows, Downside, in a photograph from 1907.

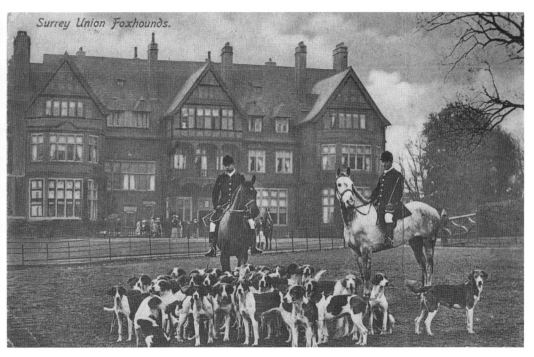

Hatchford Park near Downside, in a postcard dating from around 1904.

Tinmans Row, Downside, is around 200 years old.

Cobham's eighteenth-century workhouse, Nos 9 and 10 Korea Cottages, Tilt Road, Upper Tilt. They are now two private cottages.

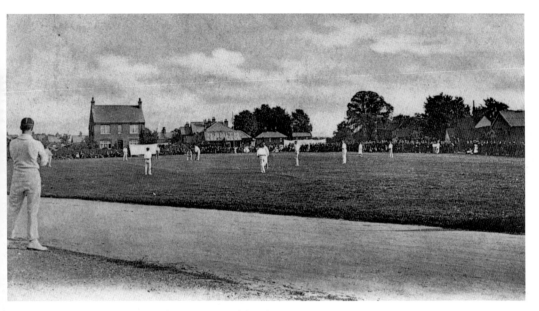

Cricket on the Tilt Green, from a postcard dated 1903.

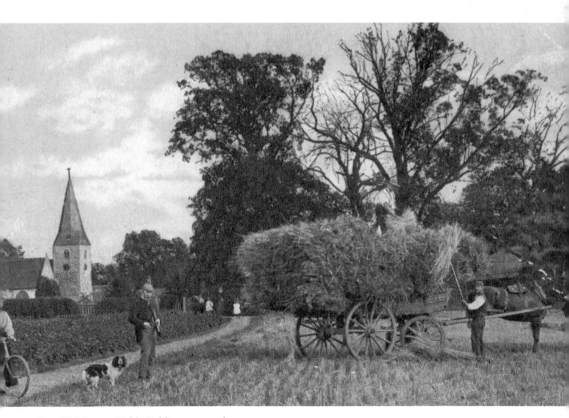

Leg O' Mutton Field, Cobham, around 1905.

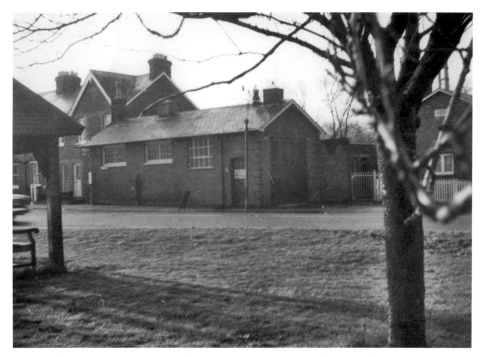

The old fire station at the Tilt. It closed in December 1964, shortly before this photograph was taken.

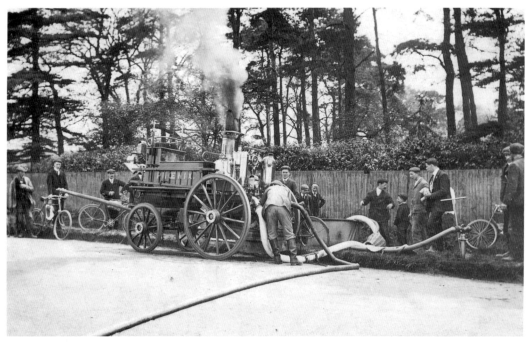

The first Cobham fire engine, which was drawn by two horses. This photograph was taken around 1901.

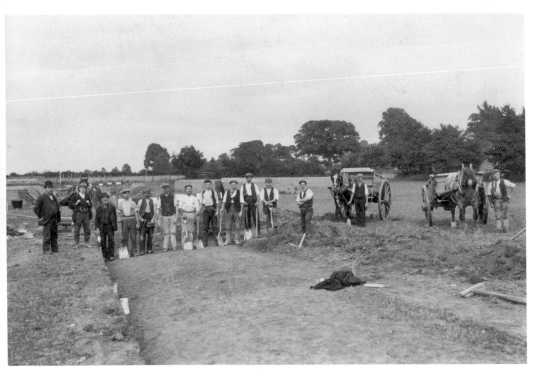

Above & below: Construction work on Freelands Road is underway in these two images dating from 1907/08. The houses shown below are the first eight completed in the road.

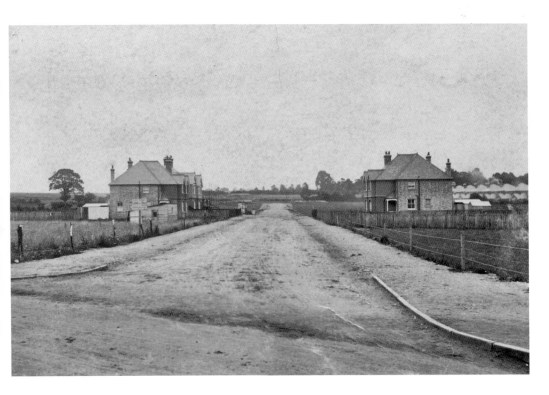

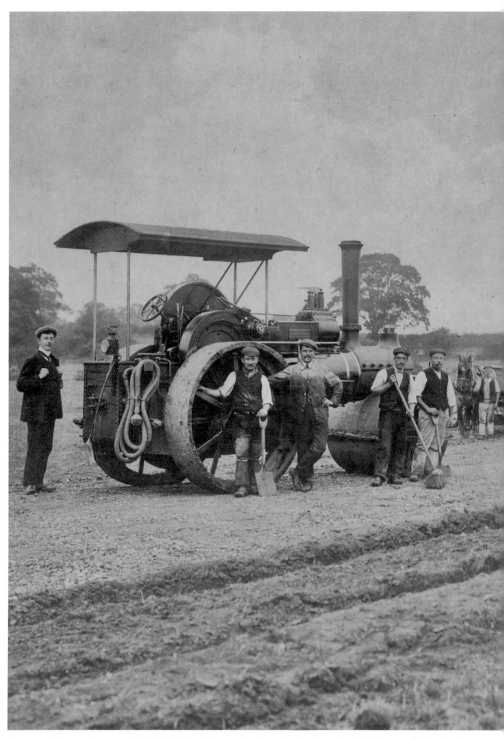

Construction workers at Freelands Road, 1907/08. William West, the developer of Freelands Road, stands at the extreme right, and his son Allen is to the extreme left.

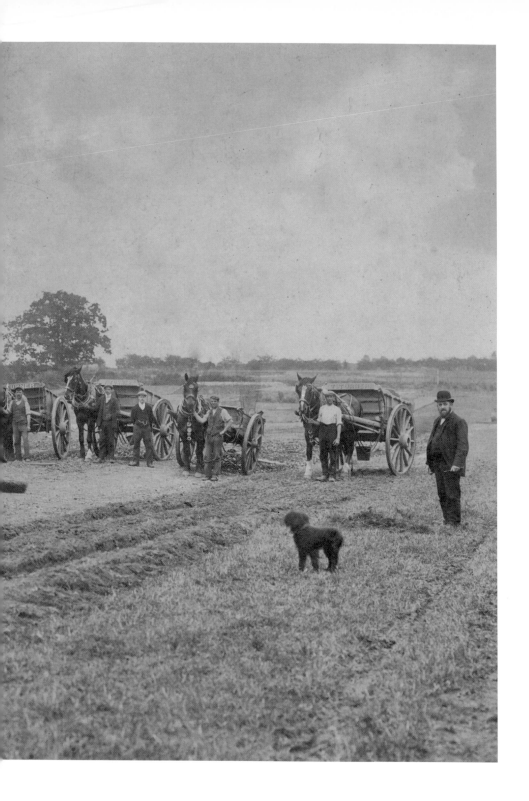

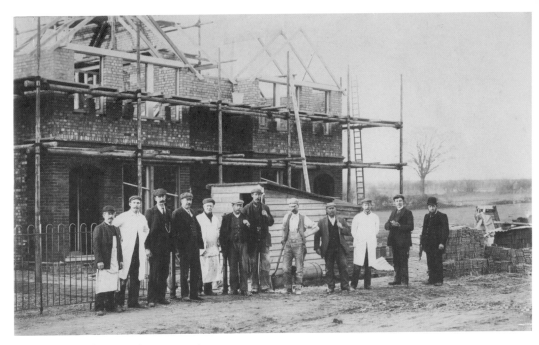

Above: A house under construction.

Below: The house completed.

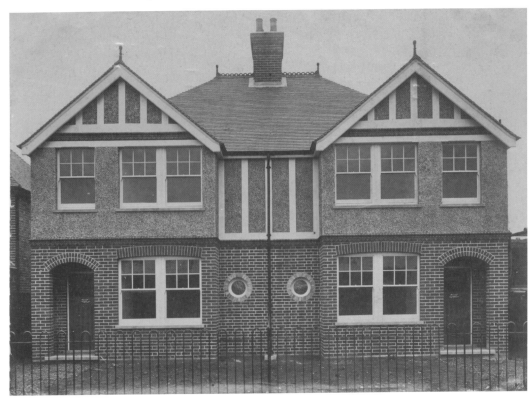

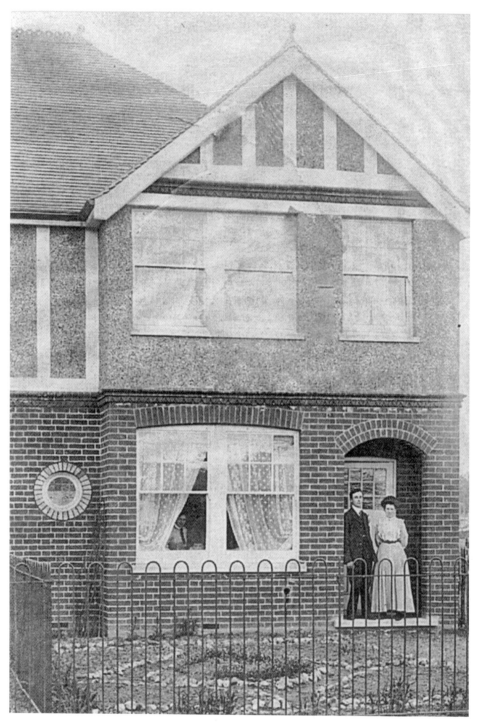

The first occupants of this newly built property in Freelands Road are pictured in their doorway, *c.* 1908.

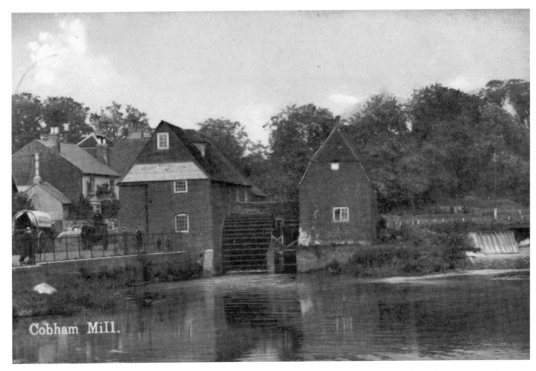

The Cobham Mill, from a postcard dated 1907. The present mill was constructed in the nineteenth century, but there had been mills here much earlier. The part that protruded into the road was demolished in the 1950s. The remaining part was restored in 1993.

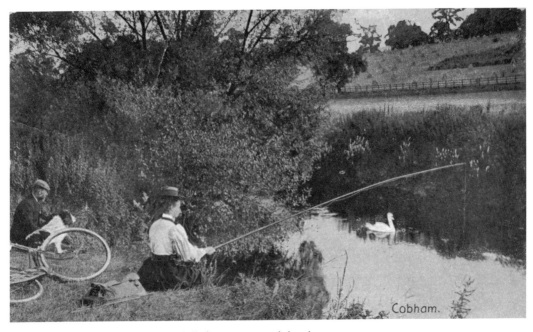

Fishing in the River Mole near Painshill, from a postcard dated 1905.

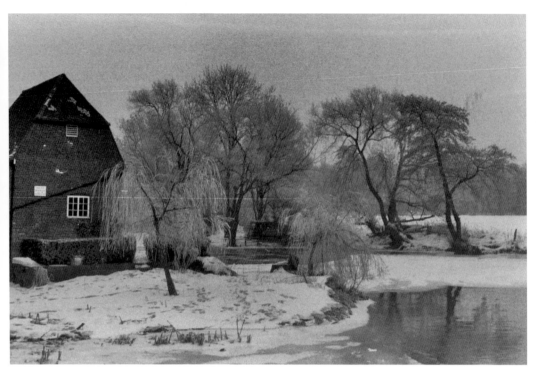

Above & below: The River Mole, near the mill at Cobham, frozen over in February 1963.

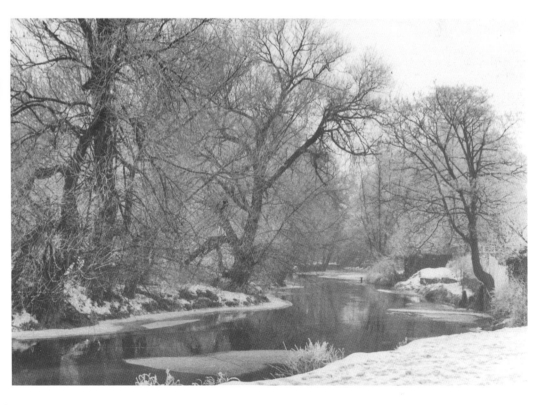

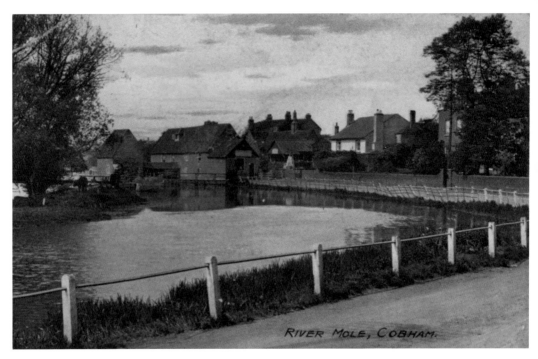

The River Mole and Cobham Mill in a postcard dating from around 1911.

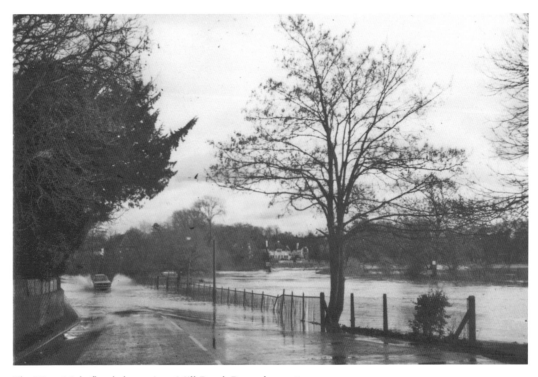

The River Mole flooded over into Mill Road, December 1982.

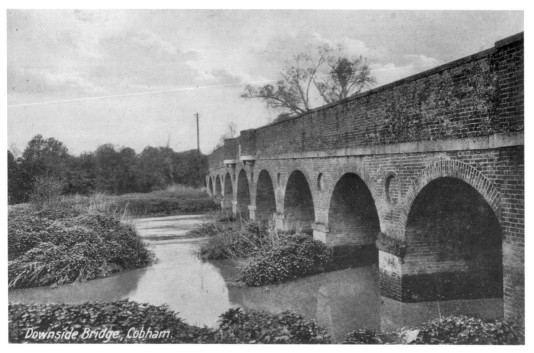

Downside Bridge in a postcard dating from around 1905. It was built in 1786 and rebuilt in 1968 after it was destroyed by flooding that caused the centre section to collapse.

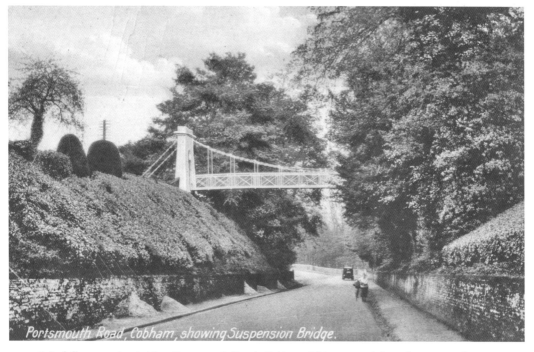

Painshill suspension bridge, Portsmouth Road, Cobham. This postcard dates from around 1910.

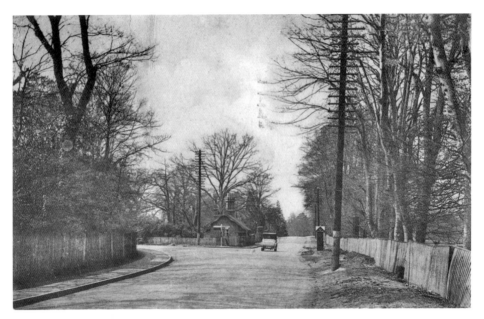

The top of Painshill and the junction of Portsmouth and Byfleet Roads are seen in this 1930s postcard. In the 1920s and '30s, the local AA patrol man George Gurr was stationed here with his motorcycle and box-sidecar, saluting AA members as they passed. He lived at Plough Cottages, Plough Corner, on the Downside Road. The AA telephone kiosk is on the right.

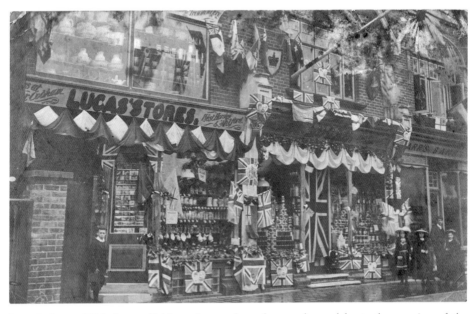

Lucas's Stores, High Street, Cobham, is seen here decorated to celebrate the opening of the Cobham Cottage Hospital on 29 June 1905. Parr's Bank is on the right, with four people standing outside. Today, Lucas's Stores is occupied by CHK Mountford and Fat Face, while Parr's Bank is now the NatWest Bank premises.

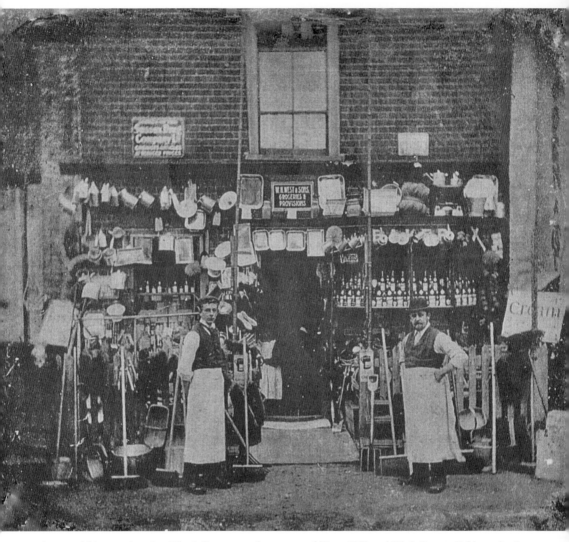

A very old image showing West's Stores, on the corner of River Hill and High Street, Cobham, in the 1890s, with Allen West (left) and William West (right).

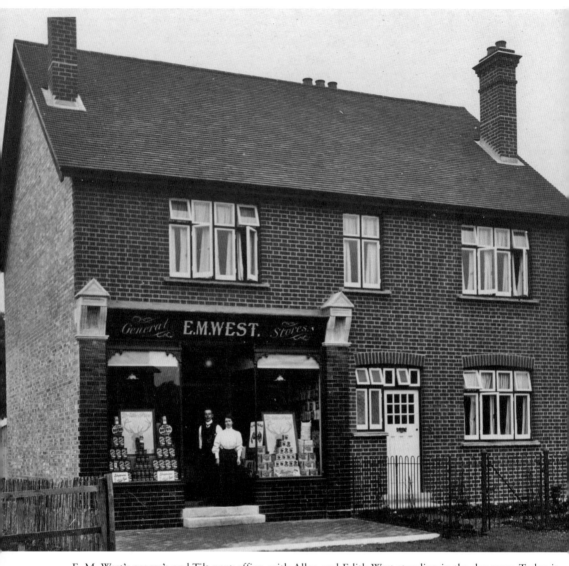

E. M. West's grocer's and Tilt post office, with Allen and Edith West standing in the doorway. Today it is a private house.

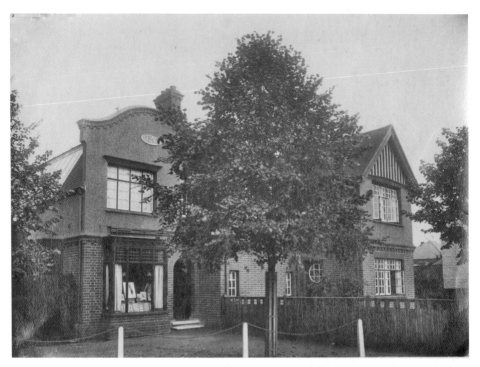

Above: Hugh West's photography studio and house, Anyards Road, 1910s.

Below: Hugh's house again, in the snow, *c.* 1914.

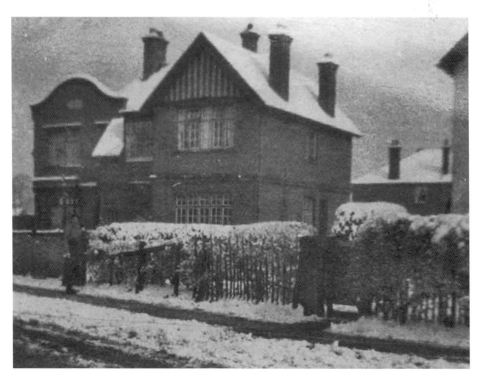

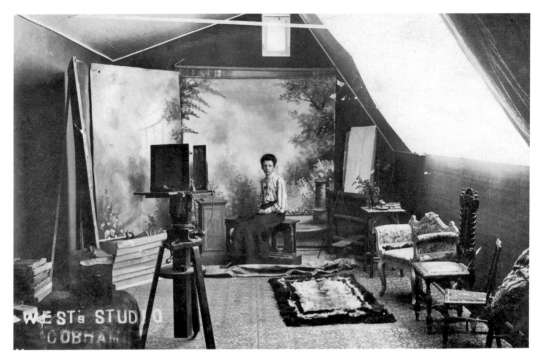

An unusual internal view of Hugh West's photography studio. He is responsible for taking many of the old images in this book.

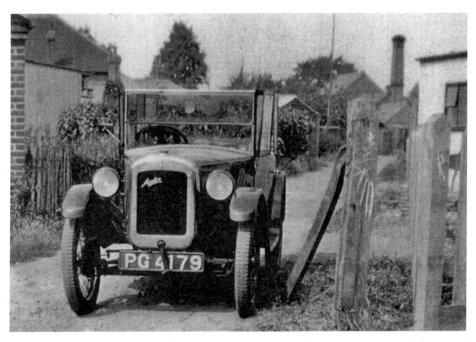

The passageway from Freelands Road to Weller's Bakery, and the rear entrance to Colin West and John R. Redfern's premises. This car was an Austin 7 belonging to F. J. Cornell. Vsible behind it is John R. Redfern's garage.

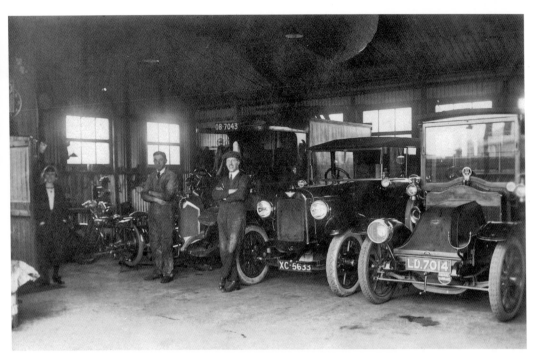

Above: Chase's Garage, Anyards Road, in the early 1920s, in which Hugh West had a share. It moved to Street Cobham in the 1930s. From left to right, the cars are a Crossley, an Austin 20 and a Renault.

Below: The Austin 20 is seen outside the West studio.

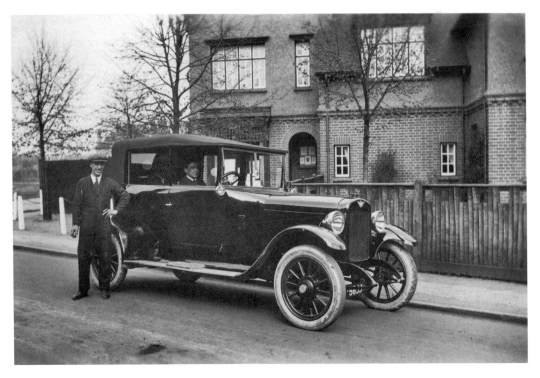

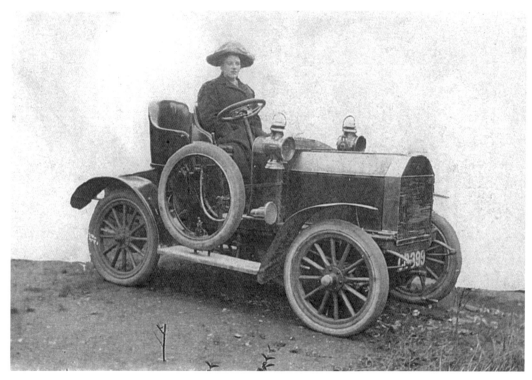

Kathleen West sitting in Hugh's car, around 1910.

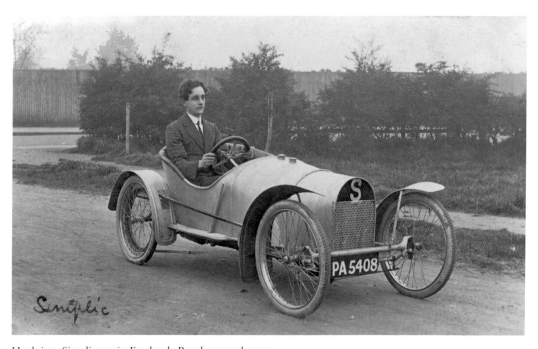

Hugh in a Simplic car in Freelands Road, around 1912.

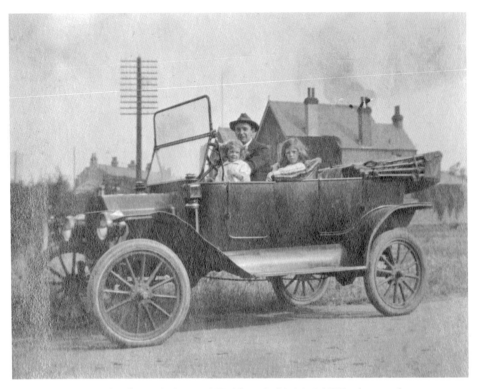

Hugh with his two daughters, Audrey and Kathleen, in his Model T Ford, around 1919.

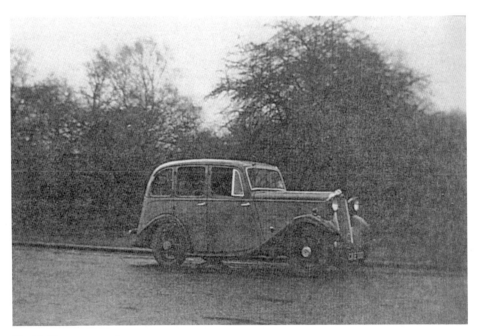

Hugh's Singer 9, 1936.

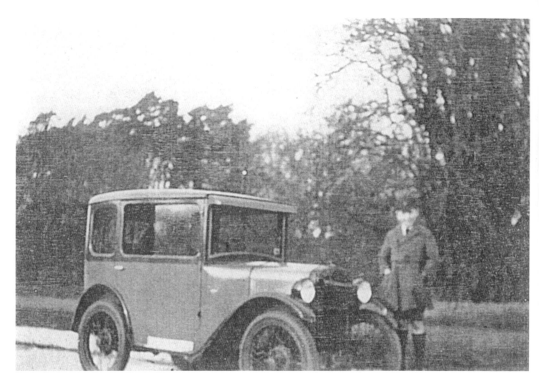

Philip West standing beside his father's Austin 7, 1931.

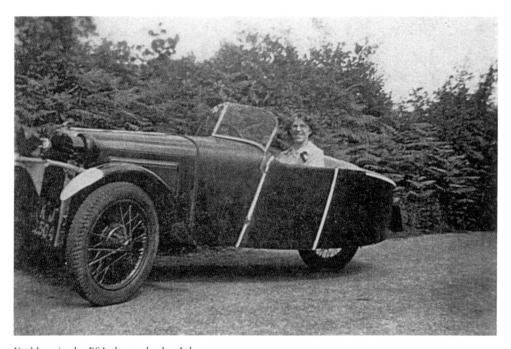

Kathleen in the BSA three-wheeler, July 1941.

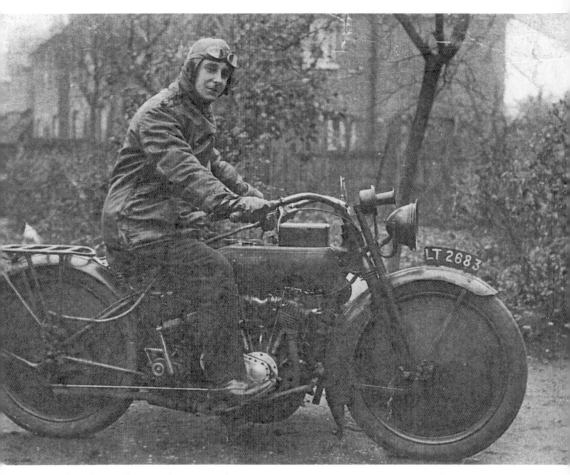

Hugh on his Harley Davidson, around 1919.

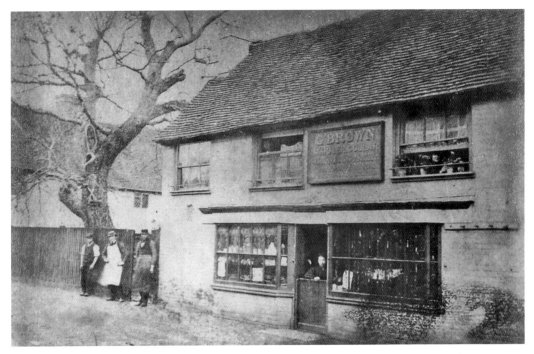

This very early image shows George Brown's saddle and harness maker's shop, opposite Church Street, towards the end of the nineteenth century.

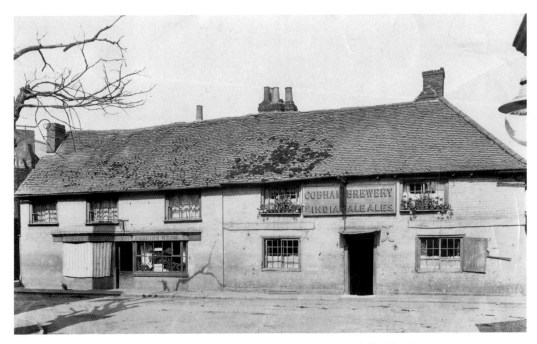

By 1904 it had become the Cobham Coffee House & Reading Room (left). The Crown Inn is next door, on the right.

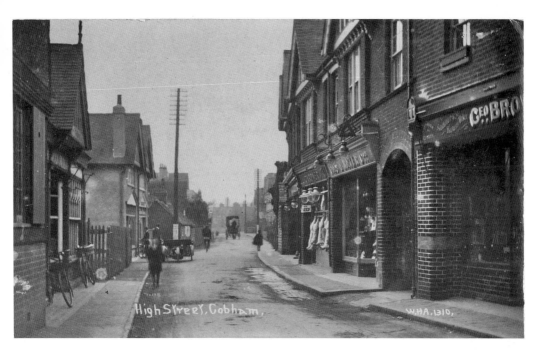

Above: Cobham High Street, *c.* 1912. On the far right can be seen the premises of George Brown's shop. On the left is H. Kippin's fishmonger's, with the bicycles outside it.

Right: Browns' sport shop is pictured here in 1964.

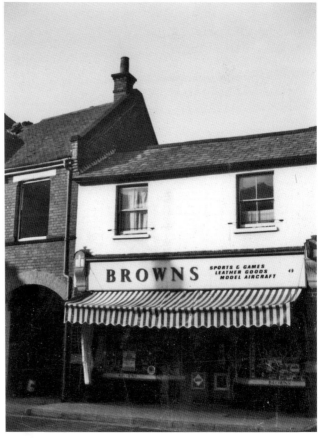

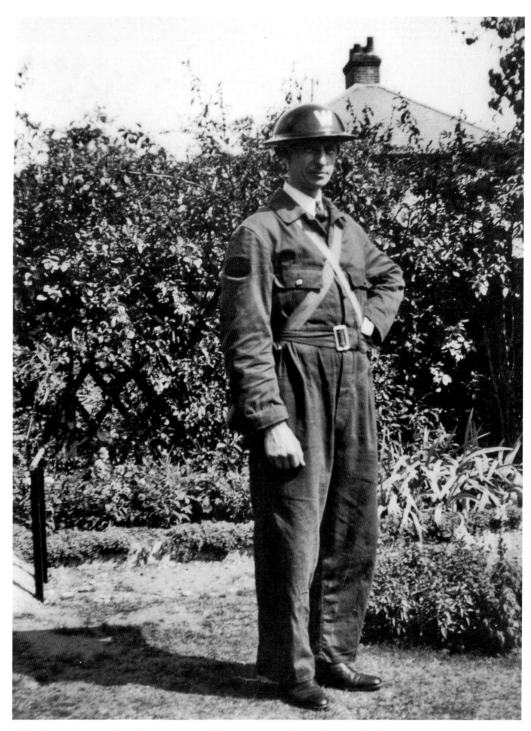

Bob Brown was an air-raid warden in Cobham 1939–41, before joining the Army.

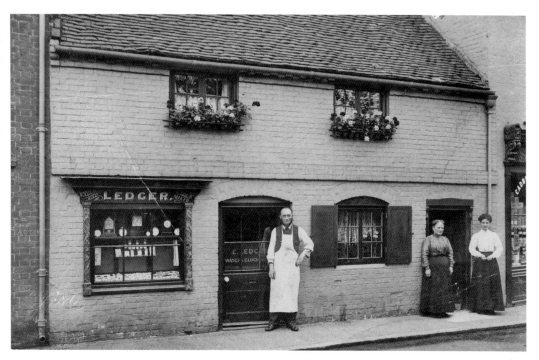

E. Ledger, watchmaker, stands outside No. 5 Church Street, Cobham. This photograph dates from the 1890s.

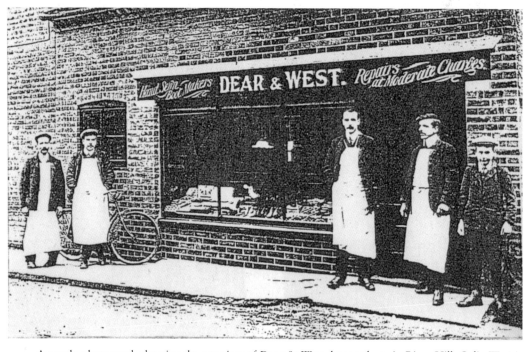

An early photograph showing the premises of Dear & West, bootmakers, in River Hill. Colin West is pictured second from the right.

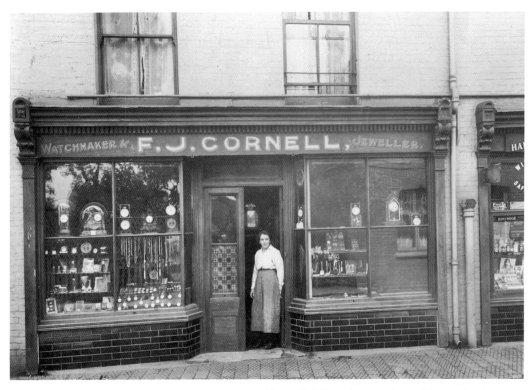

Above: F. J. Cornell's premises at No. 7 Church Street, around 1920.

Left: Ethel Cornell, also seen standing in the doorway of Cornell's shop above. Ethel ran the business with her husband, and continued to do so for three years after he died in 1950.

F. J. CORNELL

39 HIGH STREET

COBHAM

WATCHMAKER

JEWELLER

SILVERSMITH

ESTABLISHED OVER 25 YEARS

MAKE US YOUR PRESENTS HOUSE

This advertisement for Cornell's shop dates from 1937.

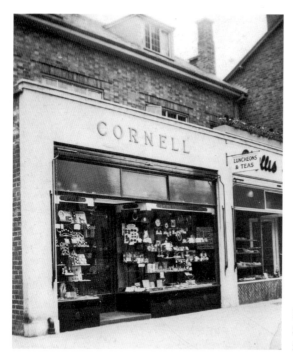

F. J. Cornell's jeweller's shop, No. 39 High
Street, 1937. The Cornells had moved here
from Church Street the previous year.

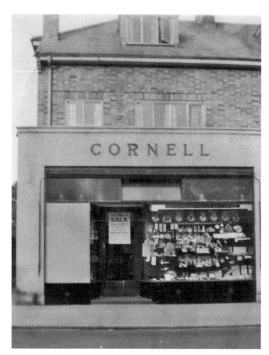

These images were taken in 1937, following a 'smash and grab' raid on Cornell's shop.

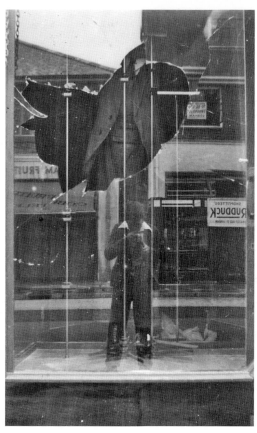

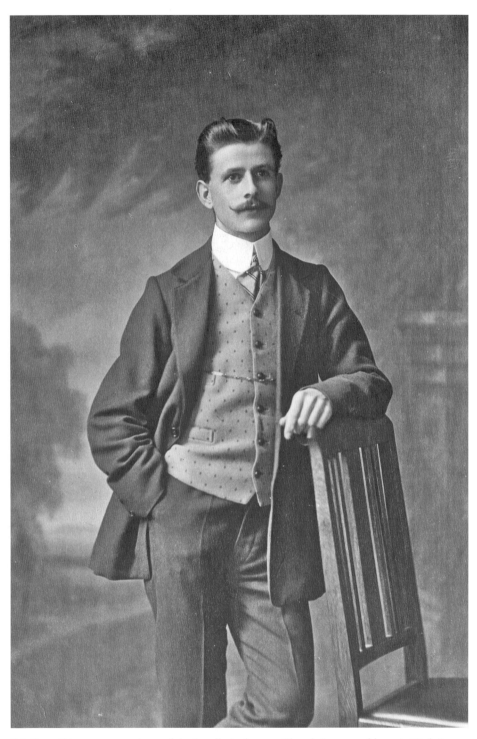

F. J. Cornell in 1913, proprietor of the jeweller's shop on Church Street, and later in High Street.

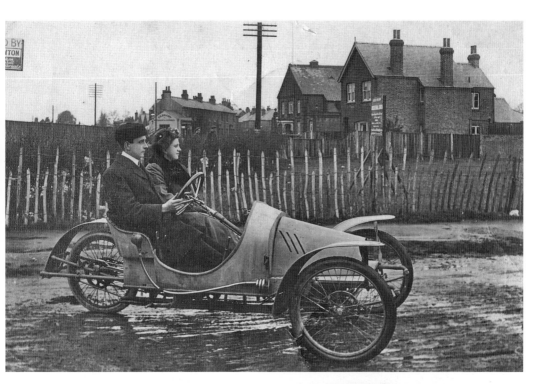

Above: In the car, in
Freelands Road, are Hugh
and Kathleen West. In the
background is the site where
Colin West built his shop in
1922. Behind that is Redfern's
dental surgery.

Right: A portrait of Colin
West.

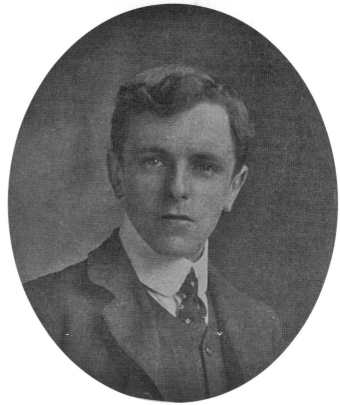

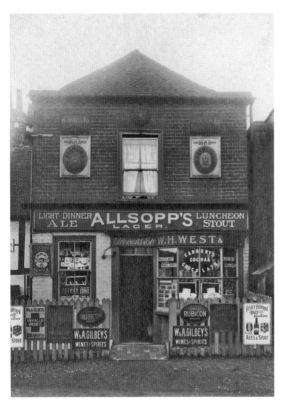

Two images of West's store, at the corner of River Hill and the High Street. The above image was taken in 1905, while the image below dates from the 1920s.

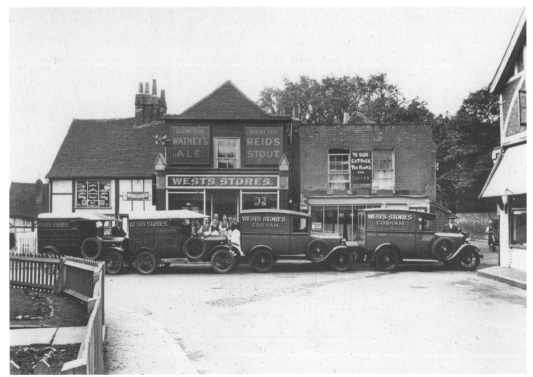

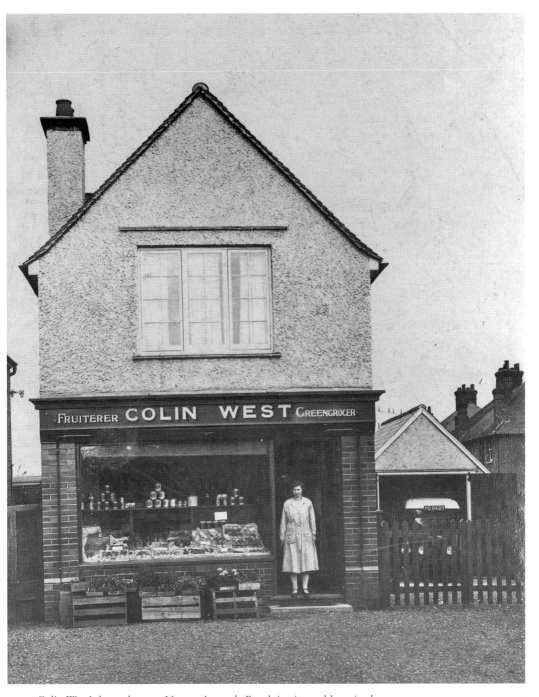

Colin West's later shop, at No. 30 Anyards Road, is pictured here in the 1920s.

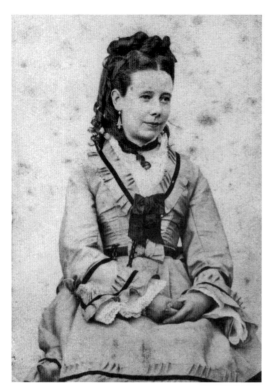

Elizabeth (top) and Marianne Bridgen (bottom) ran a draper's and millinery shop during the 1910s. These portraits were probably taken in the 1880s.

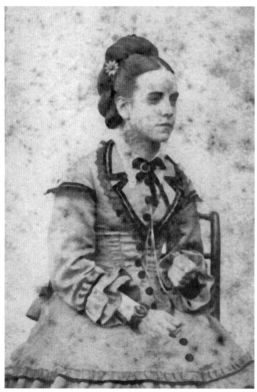

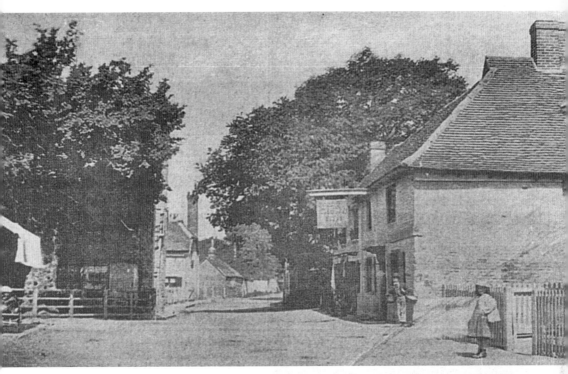

Above: Cobham High Street, *c.* 1870. James Bridgen's general store is on the far left, while the Crown Inn is on the far right, with George Brown's shop behind it.

Right: James Bridgen, proprietor of the general store in the High Street, *c.* 1880.

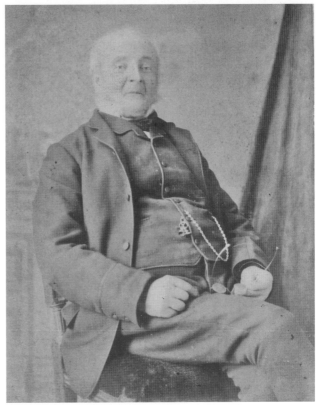

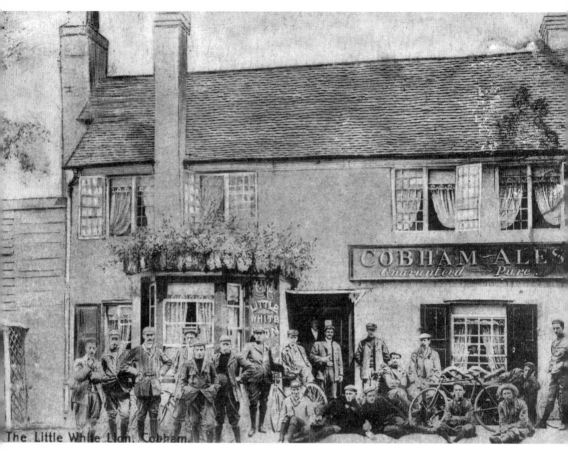

The Little White Lion, Cobham.

The images that follow show some of Cobham's old public houses. We start with this delightful and very old photograph of a cycling club at the Little White Lion Inn, Portsmouth Road, Street Cobham, believed to have been taken around 1906. Today, the Little White Lion is a restaurant known as Loch Fyne.

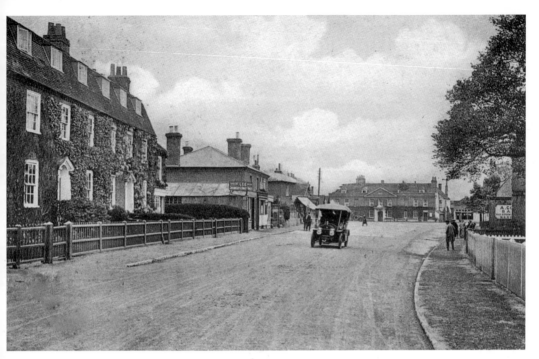

Portsmouth Road, Street Cobham, around 1908. The White Lion Inn (not to be confused with the Little White Lion) is seen in the distance.

Street Cobham, from a postcard dating from around 1911. On the right is the Village Club, while on the left is the White Lion Inn. The White Lion Inn at Street Cobham as it is today, now the NY bar and grill. The White Lion and the Little White Lion were two of Cobham's oldest inns, serving coaches and travellers on the Portsmouth Road as far back as the eighteenth century.

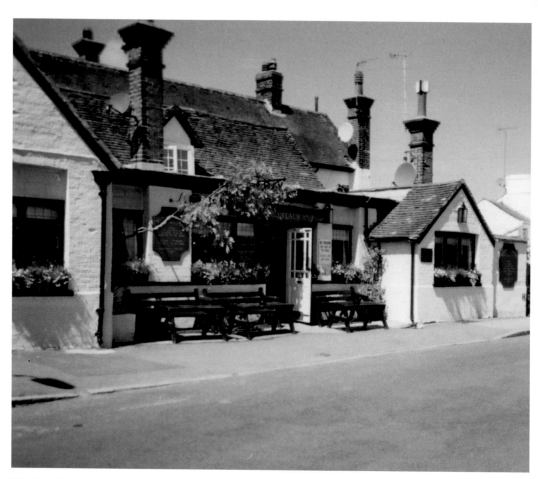

The Running Mare, Tilt Road, the Tilt.

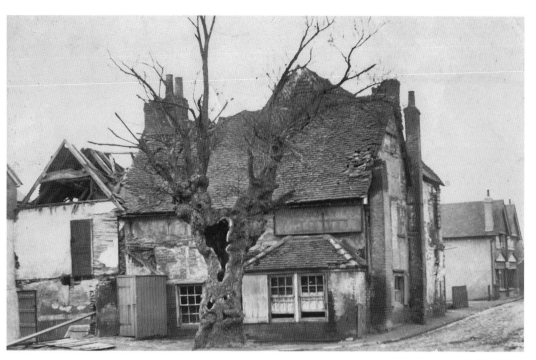

The old Fox & Hounds in the 1890s, just before it was demolished and rebuilt around 1900.

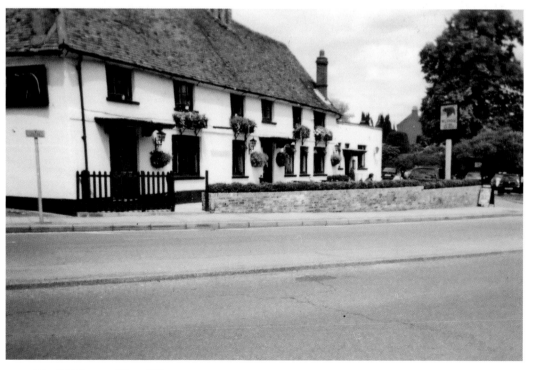

The Old Bear at River Hill.

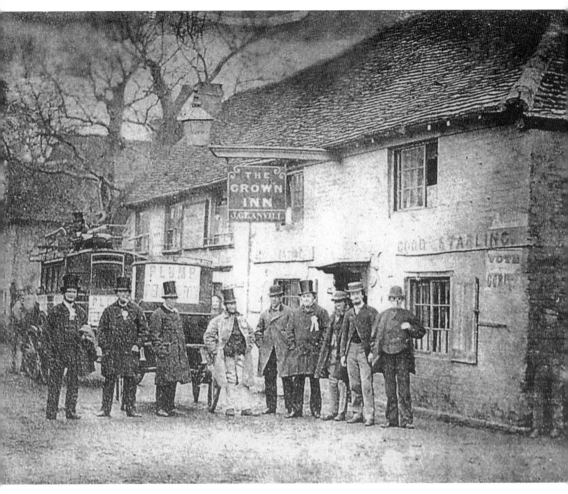

The Crown Inn in the High Street, opposite Bridgen's, with an election group outside, *c.* 1877.

The Old Plough, Station Road, Stoke D'Abernon.

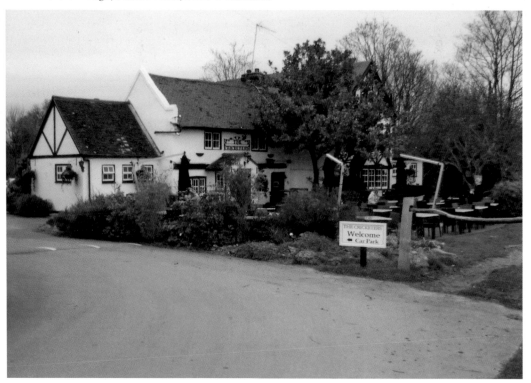

The Cricketers, Downside Common.

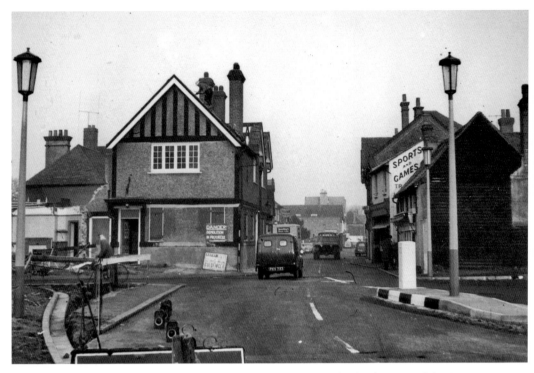

This page and next: This selection of images show the demolition and redevelopment of the Crown Inn and Fox & Hounds sites on the High Street, which took place in 1965.

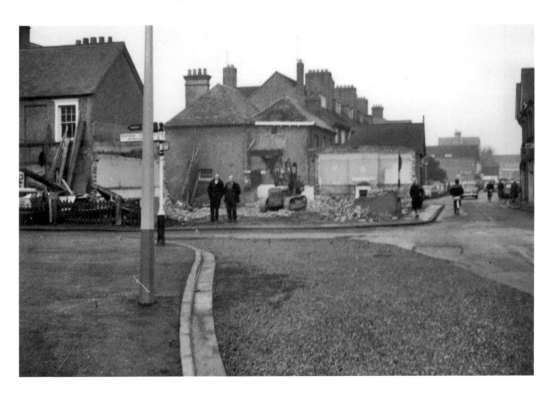

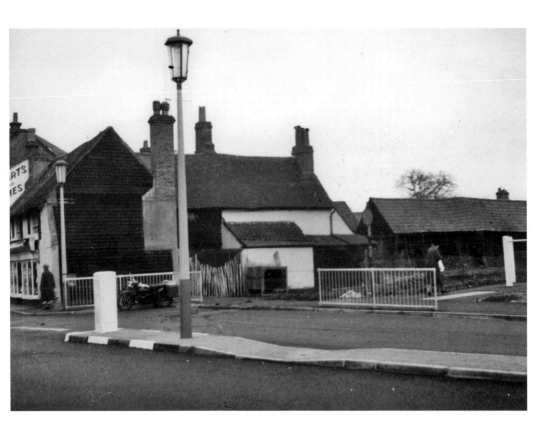

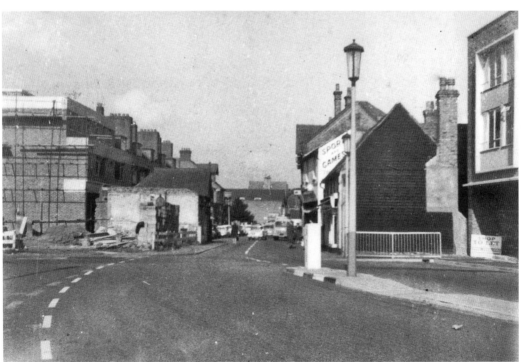

71

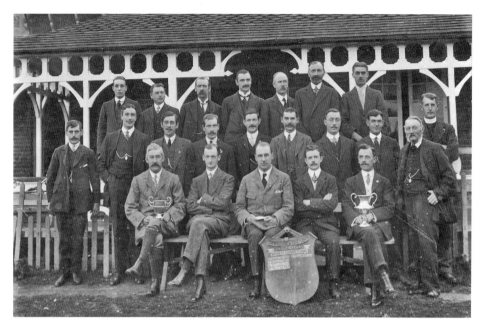

The Downside & Cobham Rifle Club, 1913. Among those pictured are A. Tidy (seated, far left), George H. W. Brown (seated, far right), F. J. Cornell (seated, second from right), H. Hale (standing, front far right), Revd P. H. B. Chubb (far right, behind H. Hale), F. Nash (middle row, third from right) and H. Kippin (middle row, fourth from right).

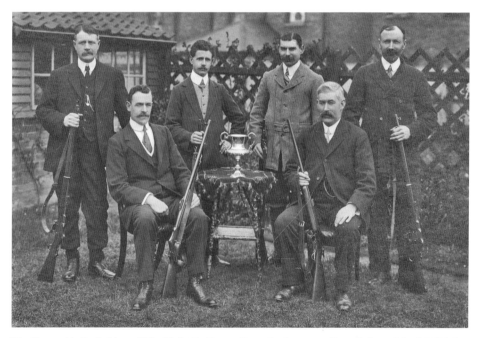

The Downside & Cobham Rifle Club Challenge Cup winning team. From left to right: H. Shipley, G. Brown, F. J. Cornell, H. Kippin, A. Tidy and E. Powell. This photograph was taken in George Brown's garden behind his shop in the High Street, in March 1913.

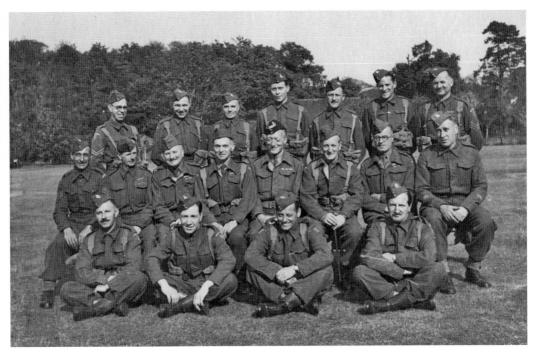

No. 13 Platoon of 'C' (Cobham) Company, 6th Surrey Battalion Home Guard, 1943. They were the leading team in England and the second in the UK in a national Home Guard rifle-shooting competition. Sgt F. J. Cornell, their rifle instructor, is seen in the centre row, second from the left.

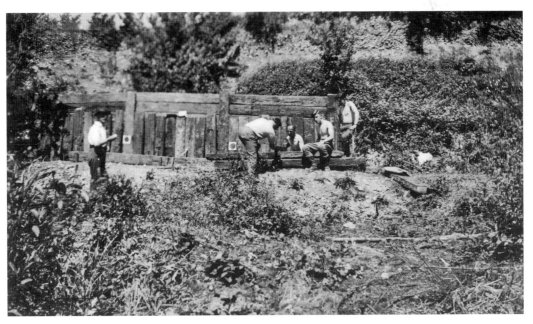

The Cobham Rifle Club range under construction at Tartar Hill, Cobham, in 1949. The club was formed by ex-members of the Cobham Home Guard. Once again, F. J. Cornell can be seen, on the left.

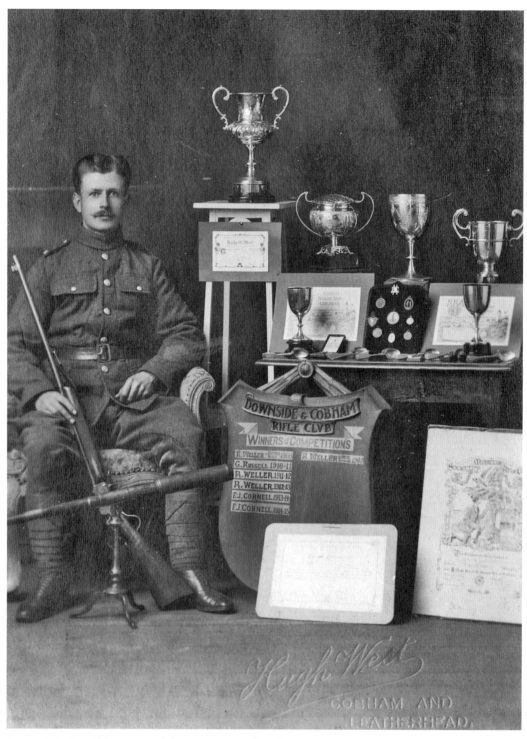

Gunner F. J. Cornell in 1916, with his pre-Army civilian shooting awards.

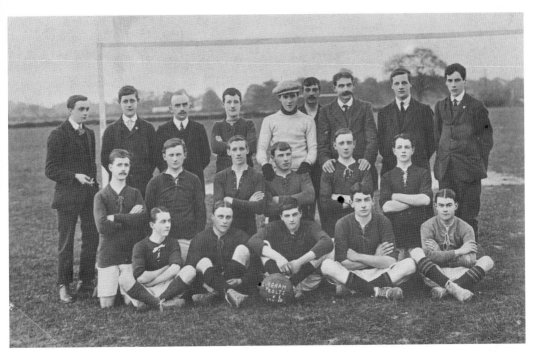

Cobham Football Club, 1911/12.

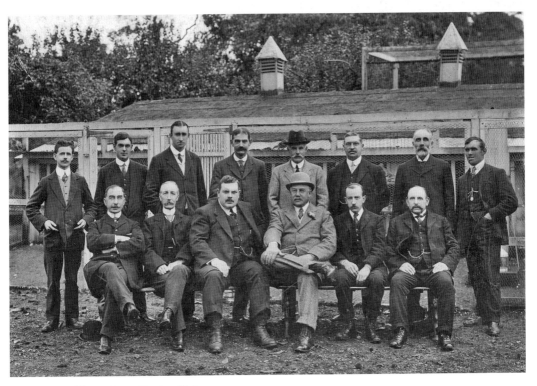

The Cobham Pigeon Racing Club, 1913.

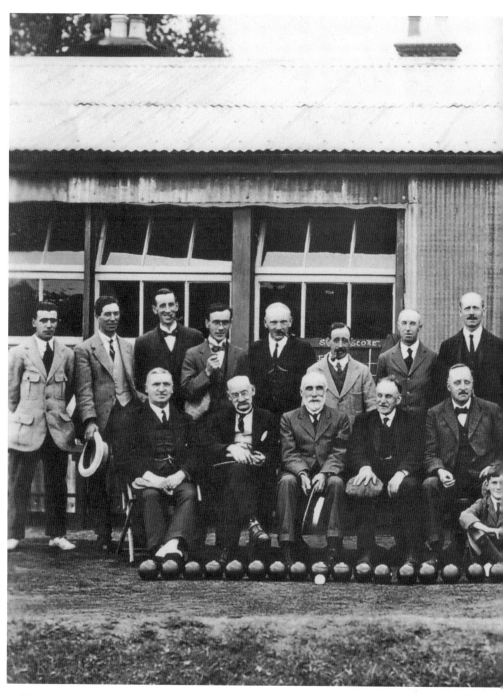

Cobham Bowling Club 1925/26. The club is pictured at the ground at the rear of the Antelope public house, Street Cobham. From left to right, back row: ? Kellard, -?-, A. Welsh, E. T. Smith, R. C. Lee, A. J. E. Faulkner, C. S. Jupp, ? Gunner, T. J. Lucas, ? Fairman, -?-, H. West, -?-, H. Kippin, George H. W. Brown, A. Goldsmith, H. J. Corbett. Seated: G. White, H. Lee, H. Weller, P. Shoesmith, G. H. Trenchard, R. Weller, R. F. Lucas, F. Caiger, T. B. Punchard, G. C. Farrent, R. L. Etherington. Front seated: Dudley Lucas.

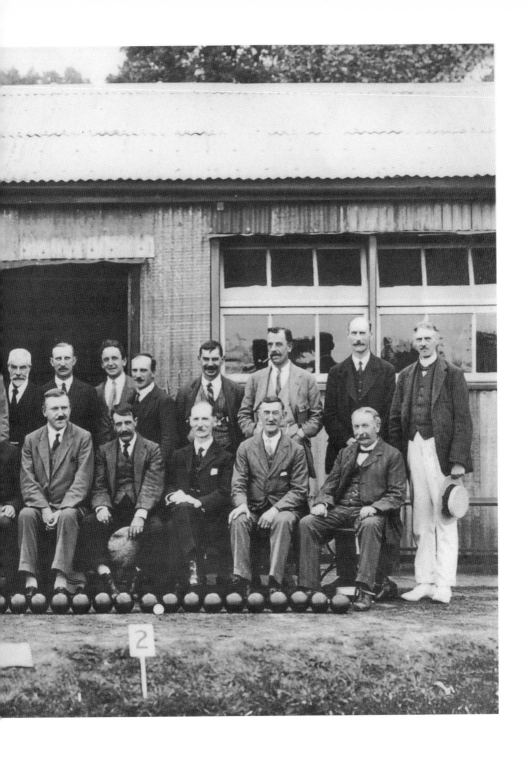

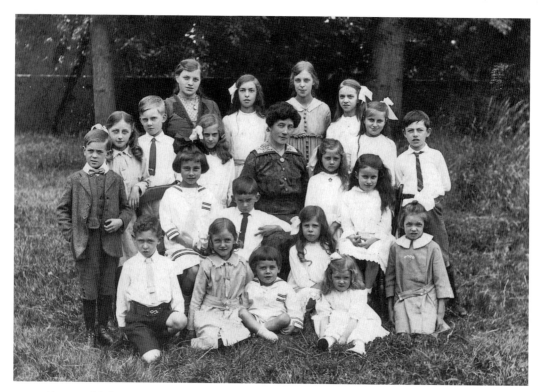

Above and below: Miss Sidebotham's school is pictured at the village club around 1917/18. Among the pupils are Bob Brown, Kathleen West, Audrey West, Dudley Lucas, Ella Kelsey, May Goldsmith, and Peggy Spencer.

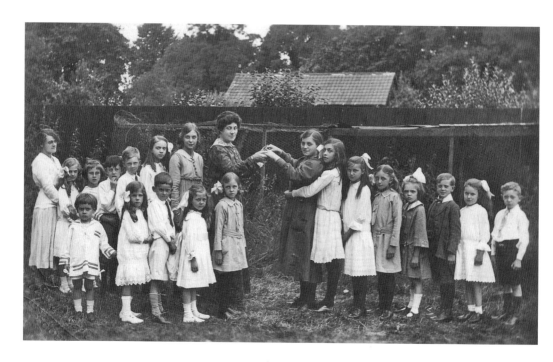

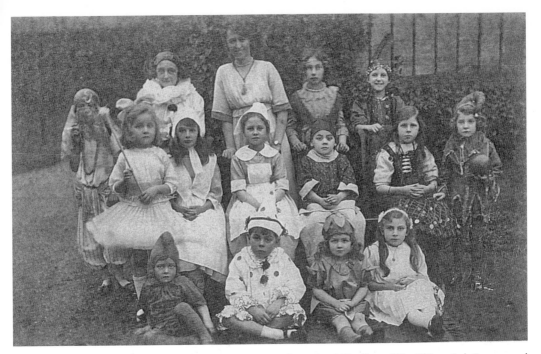

Party in Hugh West's garden. Among those pictured are Curtis Redfern, Alfred West, Bob Brown, and Kathleen West.

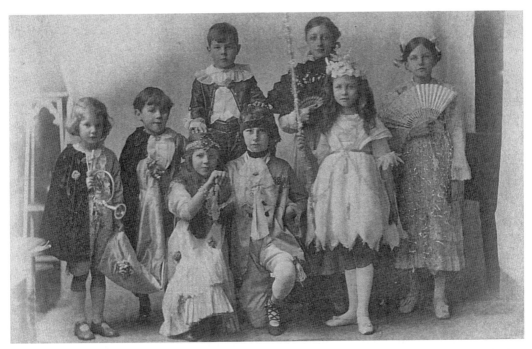

Cinderella, 1921. From left to right, back row: Curtis Redfern and Mary Spencer. Front row: Audrey West, Bernard Fillingham, Kathleen West, Grace FIllingham, Mary Scott and Peggy Spencer.

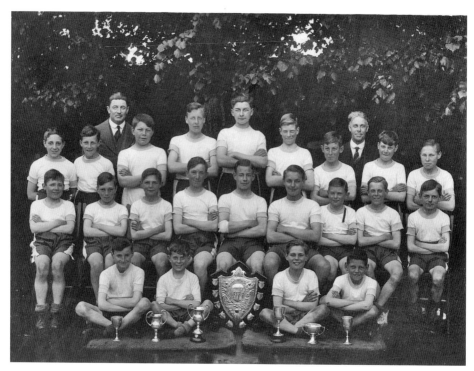

St Andrews School athletics team, *c.* 1934. Headmaster Mr James Boulden is on the left and sports master Mr J. Whiteley is on the right.

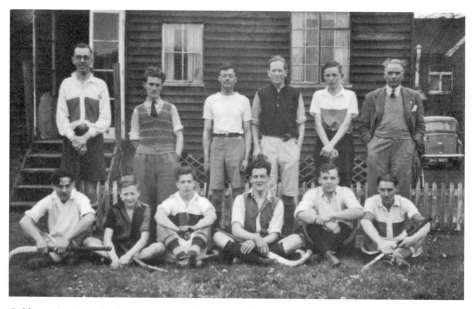

Cobham Avorians hockey team, outside the clubhouse on the Fairmile, Portsmouth Road, around 1939. Those who can be seen include R. Plant (front row, far left), P. Cornell (front row, third from left), W. Bishop (front row, second from right), J. Woods (front row, far right), and G. Osman (back row, far left).

Cast.

The Mikado of Japan J. LONGHURST
Nanki-Poo (his son in disguise) ... {T. STACEY or / V. ABBOTT}
Ko-Ko (Lord High Executioner) ... D. HARBER
Pooh-Bah (Lord High Everything Else) E. WINTERBORNE
Pish-Tush (a Noble Lord) W. STENT
Yum-Yum ⎫ ... V. SIMMONS
Pitti-Sing ⎬ Three Sisters, Wards of Ko-Ko J. BAKER
Peep-Bo ⎭ ... O. CHURCH
Katisha (an Elderly Lady) M. BISHOP

School Girls.

K. Bryan, P. Chew, S. Goodman, J. Gray, O. Groves, L. Gurr, J. Gutsell, M. Headon, A. Lindsay, J. Longhurst, J. Pearce, J. Pickett, J. Russell, N. Skelton, J. Small, E. Stedman, K. van den Steen, F. Still, J. Tapping, M. Williams, J. Wood.

Noble Lords.

A. Brittin, P. Burgess, R. Byles, G. Cane, A. Dodd, D. Evans, D. Fuller, L. Hatcher, J. Head, H. Killick, N. Maskell, R. Millard, E. Millis, E. Mills, S. Morum, G. Osborne, R. Plant, J. Rainford, D. Sayers, R. Short, K. Simpson, A. Steer, R. Warner, E. Weller.

Attendants.

E. Church, J. Combes, P. Moore, D. Rainford, L. Taylor, V. Woodgate.

ACT I. Courtyard of Ko-Ko's Official Residence.
ACT II. Ko-Ko's Garden.

The entire production, Costumes, Programmes, Posters, Scenery, etc., has been carried out by the Children under the direction of the Staff.

Producer and Musical Director.
Mr. James Boulden, L.R.A.M., A.R.C.M.

Costumes, Programmes and Posters.
Miss O. M. Taylor, Final Needlework Diploma, C.G.L.I.

Scenery and Stage Properties.
Mr. Charles Dawson, Final Handicraft Diploma C.G.L.I.

Business Manager.
Mr. J. E. Whiteley.

Stage Managers.
Miss E. M. Osborne and Mr. F. Walmsley, B.Sc.

At the Piano.
Mrs. James Boulden, A.R.C.M.

Mr. J. R. REDFERN'S ORCHESTRA.

Violins—Mrs Headon, Mrs. A. F. Scott, Miss V. Ponsford, Mr. D. Osman and Mr. J. R. Redfern.
Viola—Mr. E. J. Chapple. *'Cello*—Mr. A. F. Scott.
Double Bass—Mr. W. G. Snelling.
Flute—Mr. R. S. Dodd. *Trumpet*—Mr. J. Etherington.

Above & below: The programme and cast list from a 1936 school performance of *The Mikado*. Mr Boulden also successfully staged two other Gilbert & Sullivan operas earlier in the 1930s, also at the Village Hall – *HMS Pinafore* and *Pirates of Penzance*.

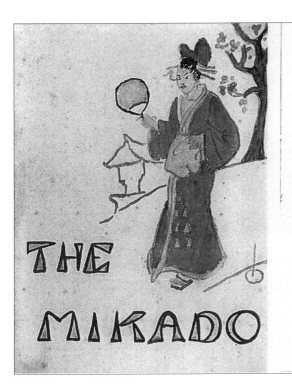

Programme.

Cobham Central C. of E. School

PRESENT

"The Mikado"

(By permission of R. D'Oyly Carte, Esq.)

IN

The Village Hall, Cobham

19th, 20th, 21st, 24th, 25th February, 1936.

Headmaster :
Mr. JAMES BOULDEN, L.R.A.M., A.R.C.M.

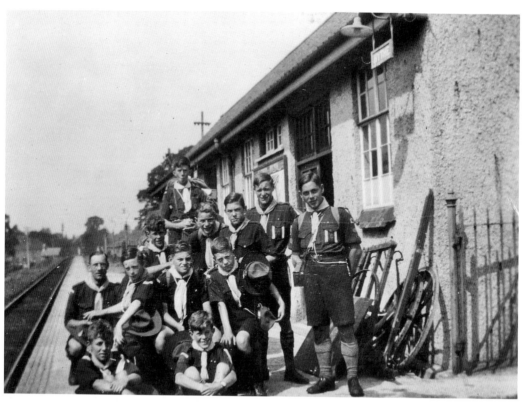

The following pages contain a selection of images showing 1st Cobham Scout Troop summer camps in the early 1930s, including trips to Sandown I.O.W., Amberley and Beaulieu.

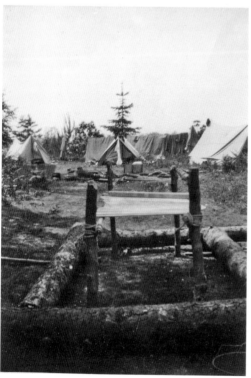

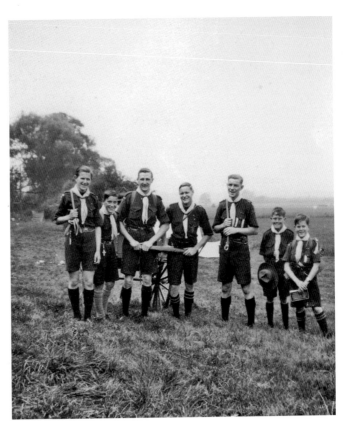

Scoutmaster 'Skipper' Cook
can be seen below in the centre
of the back row.

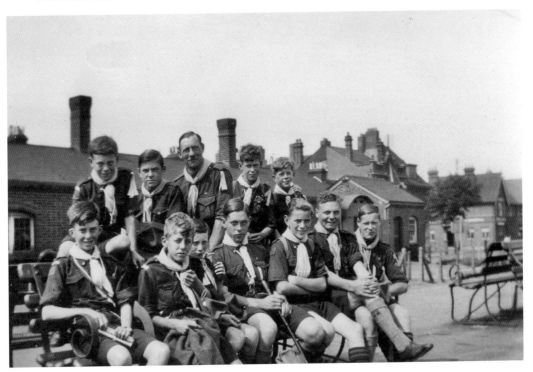

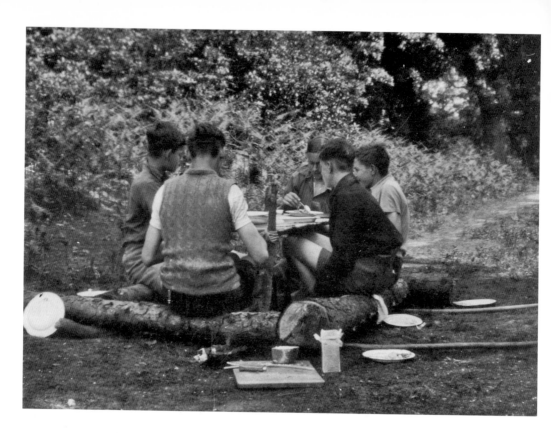

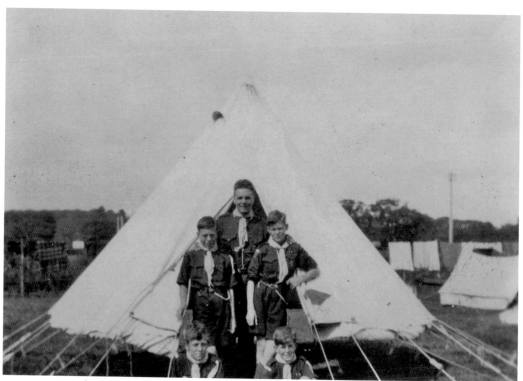

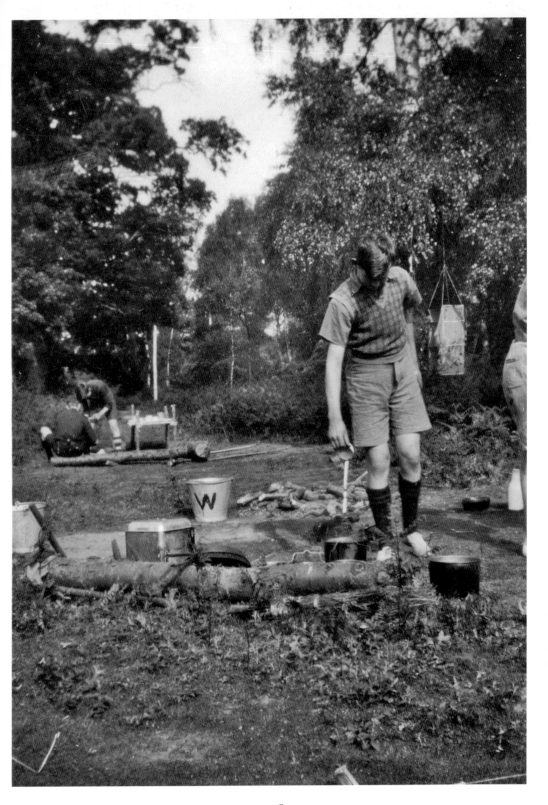

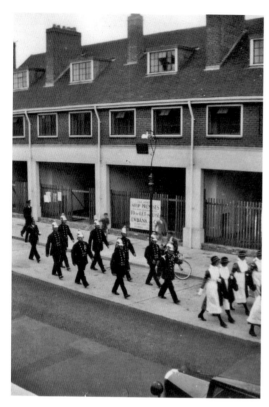

A parade through Cobham High Street by
St John's Ambulance members, the fire brigade
and Cobham Brass Band, in the late 1930s.

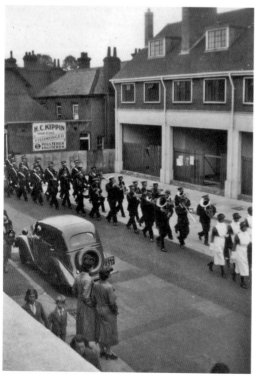

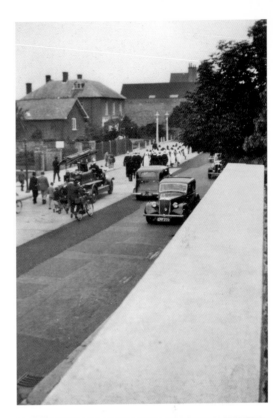

The parade continues along the High Street.

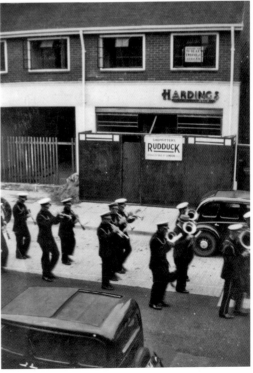

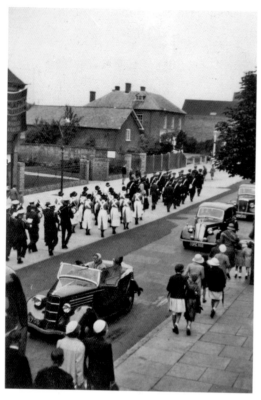

Two further views of the parade.

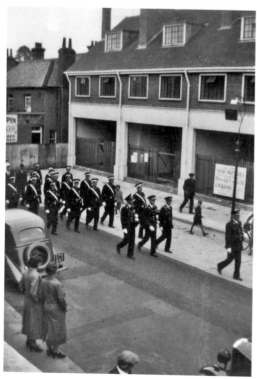

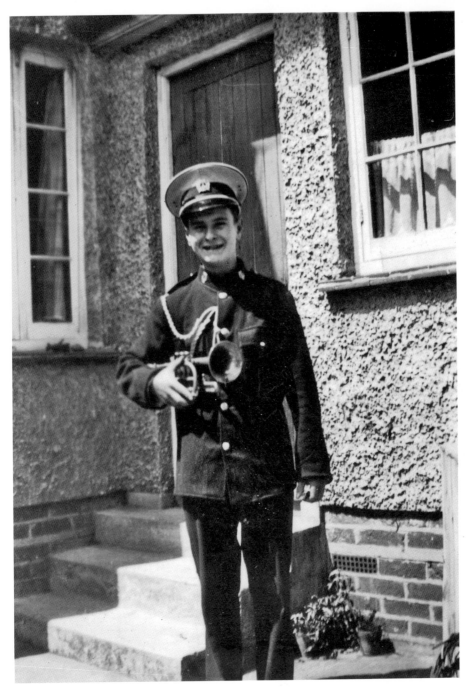

Ronald West played in the brass band featured on the previous pages.

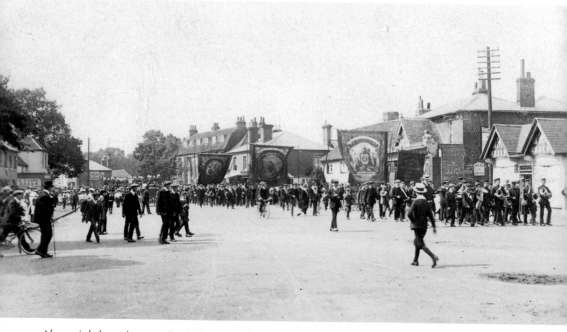

Above & below: A procession in Portsmouth Road, Street Cobham, around 1905. It is led by the band, followed by local friendly societies and fire brigade teams.

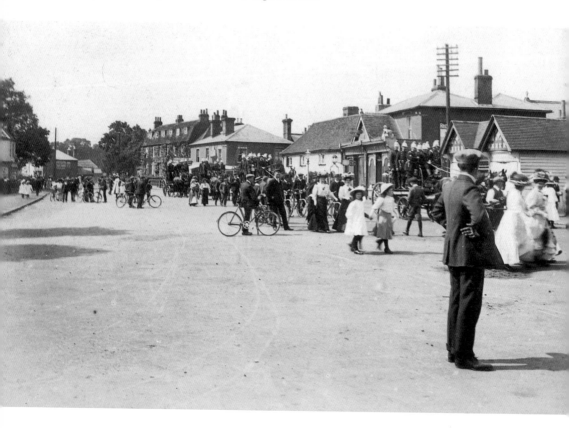

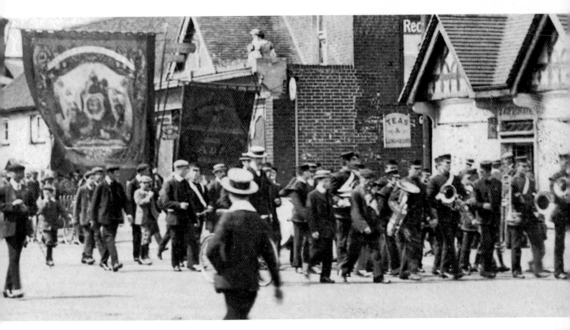

A close up of the band leading the procession.

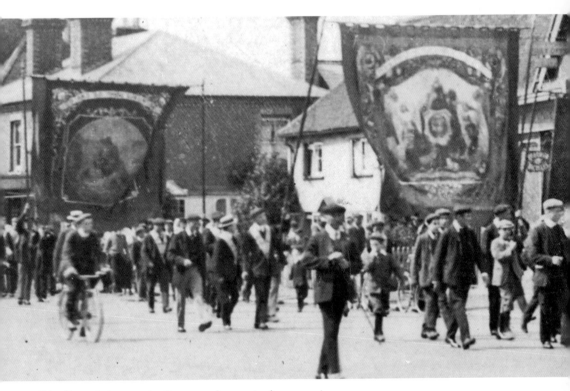

Friendly societies carrying banners take part in the procession.

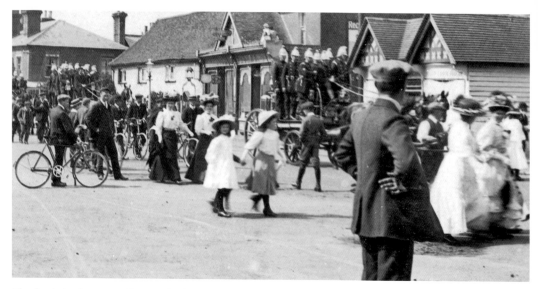

The fire brigade teams take part in the procession.

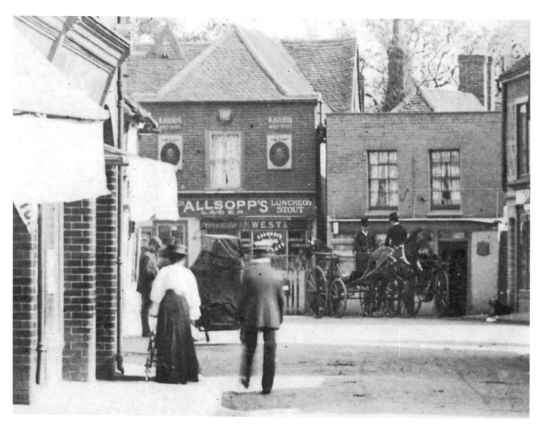

In front of West's Stores, on the corner of Cobham High Street and River Hill, there appears to be a barrel piano or street organ. There are two light carriages, or flys, facing in opposite directions on the right.

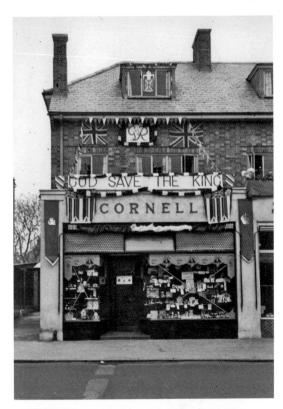

Decorations to celebrate the Coronation of
George VI on 12 May 1937.

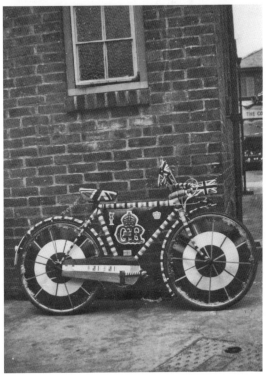

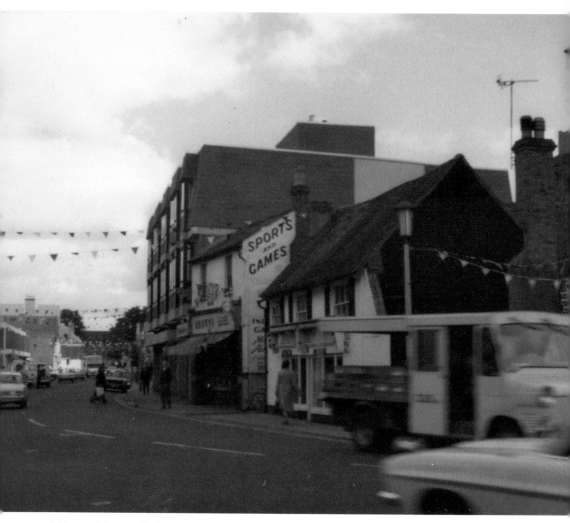

Cobham High Street looking north, during Queen Elizabeth II's Silver Jubilee celebrations in June 1977.

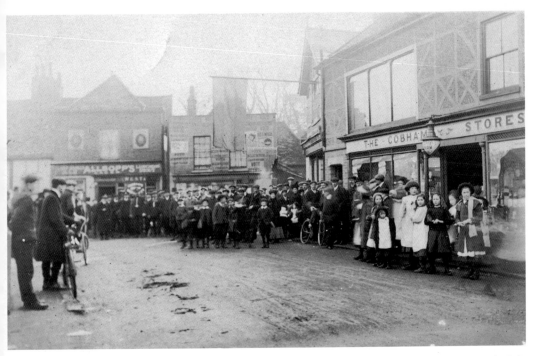

The corner of River Hill and High Street; Bridgen's former premises is on the right, West's on the left. The shop next to West's in the centre was taken over by Elizabeth and Marianne Bridgen for their drapery and millinery business.

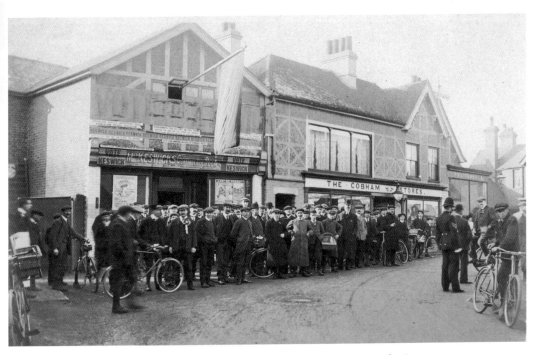

In both of the images on this page, crowds await the result of the 1910 election.

The milestone on the Portsmouth Road, opposite Northfield Road, indicates the distances to central London (17 miles), Esher (3 miles) and Ripley (4 miles). There were a series of these on the Portsmouth to London route, at 1-mile intervals, placed there in coaching times, but many have now disappeared.